CARTOONISTS DRAW THE LINE AT PARKINSON'S

Team CUL de SAC

EDITED BY CHRIS SPARKS

Andrews McMeel Publishing, LLC

Kansas City · Sydney · London

To Mom, Jennifer, and Emily
With my love

To my bookends, my mom, Thelma, who bought me my first Carl Barks
Uncle $crooge comic, and to my li'l girl, Emily,
who I hope finds as much joy from comics in her life as I have in mine.

One of the most important people in this journey has been my wife,
Jennifer, who has inspired me from the moment I met her
and was the first cheerleader for Team Cul de Sac.

Richard, I am honored to be your friend, and hope I can face my challenges
in life as commandingly as you have. Thank you, R. T.

• • •

Andrews McMeel Publishing, LLC
an Andrews McMeel Universal company
1130 Walnut Street, Kansas City, Missouri 64106

www.andrewsmcmeel.com

All artwork is copyrighted by the individual artists. Please see page 123 for specific copyright notices

12 13 14 15 16 SDB 10 9 8 7 6 5 4 3 2 1

ISBN: 978-1-4494-1966-0

Library of Congress Control Number: 2011944562

ATTENTION: SCHOOLS AND BUSINESSES
Andrews McMeel books are available at quantity discounts with bulk purchase for educational, business,
or sales promotional use. For information, please e-mail the Andrews McMeel Publishing Special Sales Department:
specialsales@amuniversal.com

CONTENTS

ACKNOWLEDGMENTS

Thank you to all the artists who contributed and everyone who has supported Team Cul de Sac. I can never express how much each and every contribution means to me. Without you, this project would have never happened.

I also need to thank just a few others who have made a difference in my life during this adventure.

Jennifer, my wife, for buying me Michael's book and supporting me on this from the very second I thought of Team Cul de Sac.

Stephan Pastis said "yes" before I had a plan formulated. With him on board, I had the beginning of an amazing list of contributors and some added confidence to ask for more!

Mike Rhode, Craig Fisher, and S. L. Gallant are a wonderful group of friends who helped me and believed in me on this project. I am so fortunate to have met these wonderful guys.

Jamie King is the other half of Sparking Design. She patiently supported this ever-growing project and was always there to help. I could never ask for a better business partner.

Lee Salem, John Glynn, Caty Neis, Dorothy O'Brien, and everyone at Universal Uclick and Andrews McMeel Publishing made this book possible and were the biggest cheerleaders for Team Cul de Sac.

Michael Cavna can make a three-hour lunch seem like a fifteen-minute laugh. Thank you for your interest in this project.

Peter Dunlap-Shohl and Tim Walker, I can never thank both of you enough for your kind words, encouragement, and being such inspirations.

Shelton Drum and everyone at Heroes Aren't Hard to Find for believing in comics and supporting Team Cul de Sac.

David Kareken pushed me, believed in me, and brought out the best in me. You were right; I needed to do a book involving my passion for comics. Here's to you!

Mike Peters, thanks for your contributions to the auction.

Sergio Aragonés, you are a mentor and a friend. Thank you for making me a better person. Without you in my life, I don't know if this project would have happened.

Bill Watterson, you are a man I have admired for years for many reasons. I am honored you picked this project to show us your work. Your contribution brought Team Cul de Sac notice from all over the world. Thank you, Bill.

Richard Thompson, you are an inspiration to other cartoonists, humorists, your friends and family, and fans. Thank you for being the poster boy for Team Cul de Sac. You were so kind to let all of us play in your sandbox. I hope you enjoy the love and support from TCDS. You are an amazing friend, and I'm glad to be a part of your extended family. Who said blundering around can't change lives? Not me! Enjoy, Richard; you are the best.

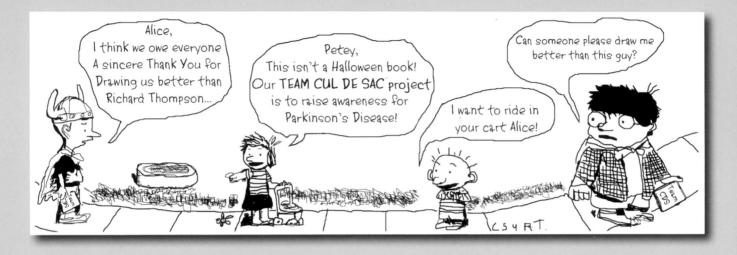

INTRODUCTION

A wealthy duck, a sword-bearing wanderer who loves cheese dip, a kid with a stuffed tiger, an alien with super-strength, a millionaire with a cowl and utility belt, a dog on his house that fights the Red Baron, a rat, a pig, a zebra, a lazy private, a cat with a food obsession, some prehistoric men. Oh yeah, and some kids living on a cul de sac.

What do all of these things have in common? They captured me in their world. As I grow in my world, I hope I never escape theirs, and I hope I continue to find ways to give back to this community.

I met Richard Thompson in the summer of 2008. We instantly became friends and, as he's said, practically family. About a year later, Richard announced he had Parkinson's disease. I was devastated to know that not only my friend, but also one of my favorite cartoonists, had this terrible neurological affliction.

I learned about The Michael J. Fox Foundation for Parkinson's Research and Team Fox as I educated myself about PD. I was inspired by Mr. Fox's drive, innovative spirit, and fearless promotion of his cause. I'm grateful for the opportunity to join the effort to find a cure. This is my chance to don my cape and tights behind a computer screen, unite fans and artists in the comics field, and have them band together to form the most formidable team of all time: Team Cul de Sac.

A heartfelt thank you to all the contributors, especially the early ones who eagerly helped me promote the project and spread the word. Team Cul de Sac succeeds because of you.

Thank you to all the people in the PD community who sent letters. You inspire me, and your words of encouragement keep me focused and strong. I can never thank you enough.

This has been a tremendous challenge, and one of the greatest blessings in my life. The art you see in the book will be auctioned as a fund-raiser, and a portion of the profits of this book will also go to MJFF.

I hope this book makes you laugh, think, learn more about Parkinson's disease, donate, be grateful for what you have in your life, and volunteer for a cause close to your heart.

Life is short. Don't waste a second of it, unless you are reading comics under a tree. That's OK, right? We can all make a difference; we just have to have the encouragement. Maybe this will be yours.

Sincerely,
Chris Sparks

FOREWORD

In the nine months between the summers of 2007 and 2008, three things happened that led to this book and the collection of drawings it holds. First, on September 10, 2007, and after almost fifty years of dawdling, I started a daily comic strip. It was called *Cul de Sac* and at its launch was syndicated to 70 newspapers.

Then, on June 21, 2008, I was at my first comics convention since high school, HeroesCon in Charlotte, North Carolina. I was trying to describe my comic strip to very few people in a very large room when a tall person walked in looking lost and asked what I was talking about.

Finally, though so gradually the date can't be fixed, I began to wonder about some small, odd things, like why the A on the computer keyboard seemed sticky to me but to no one else, and why everyone seemed to be walking faster than me and why it was becoming difficult to put a coat on.

It turned out that drawing a daily comic strip wasn't so scary—I took to it like a duck takes to soup. And it turned out the tall person who'd wandered into my under-populated talk in Charlotte was Chris Sparks, a former comic book store owner and lifetime comics fan from Asheville. Though he'd never heard of my strip and hadn't planned on attending my talk, he fell for *Cul de Sac* pretty much instantly, to my surprise and delight.

And it turned out that those small, odd things I was wondering about, the typing and the walking, etc., were symptoms of Parkinson's Disease.

By the time I found this out in the summer of 2009, other things were going haywire, like my gait and balance. My friend, Dr. Janet Smerec, didn't hesitate in diagnosing Parkinson's, though it can be a slippery disease to pin down. I've always suspected that brains are weird things. My image of how Parkinson's attacks the brain—a stream of tiny gremlins in jumpsuits sneaking through all those convolutions of mental ductwork to ransack the place of dopamine—is probably wrong (it's really an inside job). But I'm certain about the weirdness of brains and I think neuroscientists will back me up, even though they change their mind about how brains function every year or so.

While my first response was to daydream about tiny brain-gremlins, Chris Sparks had a more productive approach. I don't remember when he suggested working with The Michael J. Fox Foundation on the thing that became Team Cul de Sac, but I'm glad he did. And I'm glad that Mike Rhode and Chris Duffy, wiser than I, talked me out of my objection to using characters from Cul de Sac as a theme. As Chris Duffy pointed out, a collection of cartoons focused only on Parkinson's would be as hard to draw as to read. When Roger Langridge thanked me for letting him play with my toys I knew it would work.

My thanks to all who helped with this, Chris and Mike especially. Also Caty Neis, Dorothy O'Brien, John McMeel, and those at Andrews McMeel; Lee Salem and John Glynn and those at Universal Uclick. My love and thanks to Amy, Emma, and Charlotte, who've kept me sane while I've driven them crazy. And all the cartoonists who played so ingeniously with my toys—for them my thanks are bottomless. I'll share my stuff with you anytime.

OR when Parkinson's is defeated and we stop the tiny gremlins from stealing dopamine, you'll all get a place in the ticker tape parade.

—Richard Thompson, February 2012

PROFILE

Comic strips are ailing. He's ailing.
But in his *Cul de Sac*, Richard Thompson's funny bone passes with flying colors.

By Michael Cavna, Published: May 19, 2011
The Washington Post Magazine

• • •

Bill Watterson receives reporters about as often as Charlie Brown receives a Valentine. Long viewed as the J.D. Salinger of comics, the creator of the retired and still-beloved strip *Calvin and Hobbes* guards his privacy by rebuffing most every entreaty for an interview.

Now, however, comes a question about a certain "kid strip" cartoonist.

One name, one talent entices Watterson to give what his syndicate says is only his second interview in two decades: Richard Thompson—creator of *Cul de Sac* and father to little Alice Otterloop and her child's-eye view of life in Washington's suburbs.

"Where to start? . . . " Watterson says in an e-mail. "The strip has a unique and honest voice, a seemingly intuitive feel for what comics do best . . . a very funny intelligence . . . the artwork, which I just slobber over. It's a wonderful surprise to see that this level of talent is still out there, and that a strip like this is still possible."

On May 28, 2011, in Boston, Thompson learns whether he has won the National Cartoonists Society's Reuben Award for cartoonist of the year. It is his second straight nomination for a strip that was syndicated almost four years ago. *Cul de Sac* is carried by nearly 150 newspapers, including the *Washington Post,* where it began. It has spawned four books, a handful of animated shorts—and legions of fans.

Cul de Sac is a whimsical skip through suburban life with Alice, her friends Beni and Dill, elder brother Petey and her classmates at Blisshaven Academy preschool. It's all about sidewalk discoveries, childhood invention, parents who are one step behind their children's antics. In this skewed suburbia, the Otterloops drive a minivan whose color is so neutral "it doesn't appear in nature."

A 2007 offering is the prototypical *Cul de Sac*. Alice—"who's not afraid of anything"—is momentarily cowed by winged cicadas. Brother Petey, typically squeamish out of doors, advises: "Do what I do. Construct a distancing fantasy as a coping mechanism." Next thing we know, Alice is costuming the cicadas in napkin dresses and naming

them. By the last panel, the Otterloop parents are reading headlines about intelligent "superbugs" wearing paper clothes. "Don't tell the kids," Mom says. "It'll just scare them."

"Richard draws all sorts of complex stuff—architecture, traffic jams, playground sets—that I would never touch," Watterson says. "And how does he accomplish this? Well, I like to imagine him ignoring his family, living on caffeine and sugar, with his feet in a bucket of ice, working 20 hours a day.

"Otherwise, it's not really fair."

Watterson wrote the foreword for Thompson's first *Cul de Sac* book in 2008. The foreword to an earlier Thompson collection was written by another industry legend, Patrick Oliphant, the Pulitzer Prize-winning political cartoonist.

"I know he would hate to be termed a genius, but that is exactly what he is," Oliphant says now.

So after a measured, decades-long career ascent, Richard Thompson sits at the comics mountaintop. Still, he is keenly aware of a constant fact: The pinnacle is crumbling. Thompson—who at 53 is a year older than the long-retired Watterson—arrived at print syndication in an era of strapped newspapers and comics sections that are so shrunken they could double as eye charts.

And then there's the second cruel twist:

Less than a year after *Cul de Sac* became syndicated, Thompson learned he has Parkinson's, the incurable neurodegenerative disease that robs patients of motor skills. His deft line and lithe mind are under attack by his own cells.

Yet here is Thompson, grinning behind his wire rims on a sunny March afternoon as he walks the half-dozen blocks from a taqueria to his modest brick home in Arlington, Va. His gait is tentative. Each day with the disease, he says, brings "a new normality." But each day also brings the chance to sit at the drafting board, ink-dipped crow quill in hand, and explore new worlds.

As Alice says: "Every day, I test the boundaries of my domain."

• • •

The buttoned-down woman was dropping off her daughter at the suburban Virginia preschool before whisking off to tackle the world's concerns. This is just the sort of friction point where, morning after morning, Official Washington meets Real-Life Washington.

It was 2003, when Thompson's younger daughter was preschool age. "I was just watching and thinking: This is a strange little place they've got going here," Thompson recalls. "This single mom had a pretty good government job, dressing up every day, to go work on slightly more momentous things. Just then, the mom picked up one of those [plastic] hamster balls, and suddenly a real hamster popped out."

The mother reared back and shrieked: "My God, it's *alive!*"

In that moment, *Cul de Sac* was born.

"I was struck by adults trying to deal with this childhood reality," Thompson says. "They were completely out of their depth, with these 4-year-olds running around."

On Feb. 12, 2004, Alice debuted inside a heart on the pages of the *Washington Post Magazine*, her surname a pun on the "Outer Loop" of the Beltway. It was Thompson's Valentine to Washington—the Other Washington.

"I lived in the suburbs of Montgomery County for practically 20 years," Thompson says. "I love the place."

So what better setting to gently mock?

Thompson, who spent years as a freelance artist for government agencies, various publications and even a neighborhood deli, had been drawing the weekly comic *Richards's Poor Almanac* for the *Post's* Style section since 1997. Tom Shroder, the then-Magazine editor, urged Thompson to develop a weekly strip about Washington.

"I just thought his talent for integrating a gag in a situation, and doing it with real nuance and voice, would be perfect for developing and sustaining characters," Shroder says. "He said he'd be willing to talk about it, and we scheduled a lunch.

"It took two years to get that lunch to happen. Then it took another two years before he handed me the first dozen strips."

"I was kind of chicken [expletive] about it," Thompson says. "I have a habit of putting stuff off. Till next year."

In 2006, Lee Salem, the top executive for the Universal Uclick syndicate who signed Watterson, came across a *Richard's Poor Almanac* about the first George W. Bush inauguration, titled "Make the Pie Higher," that had gone viral five years earlier. He sent Thompson a note: "You ever thought about syndication?"

The cartoonist met Salem at a Washington hotel, toting photocopied *Cul de Sac* strips. After an affable chat, Thompson left the meeting thinking: "Well, *there's* another shot in the dark." Months later, Thompson and his family were at the beach near Charleston, S.C., when Salem called. The syndicate wanted to turn *Cul de Sac* into a daily feature.

Thompson had been reluctant to go daily. "There's the fear of the thing running dry on you really fast," the cartoonist says. Yet, "I began wondering what my characters were doing the rest of the week, beyond Sunday to Sunday," he says. "Obviously, they take on a life of their own—a novelist would tell you this—and they demand some kind of say in it."

He walked for two hours on the Carolina beach. It had been nearly three decades since he'd first published illustrations. Approaching 50, Thompson says he realized: "I really *want* this."

<p align="center">• • •</p>

American newspaper comics, for more than a century a staple of popular culture, are arguably suffering through their hardest days since 1895, when the Yellow Kid first popped in full color into R.F. Outcault's *Hogan's Alley*.

As newspapers grapple with shrinking budgets, print strip sizes have been reduced and new syndication sales have declined. *Zits* is the most recently introduced strip to reach 1,000 papers, according to syndicates; it was launched nearly 15 years ago. *Cul de Sac* is syndicated to nearly 150 papers.

"Richard's only apparent weakness is his timing—in a fair world, his brilliant reimagining of childhood would rule the comics page," says Garry Trudeau, who launched his Pulitzer-winning *Doonesbury* in 1970. "But shrinking pages have compelled comics editors to fight a cautious rear-guard action, defending the tried-and-true at the expense of the new."

"It is depressing," Thompson acknowledges. "They say in comedy, timing is everything—and I've managed to time my little splash into the field at the worst imaginable time."

When was the last heyday for print comics? Many fans mourn 1995, when three superstar strips—*Calvin and Hobbes*, *The Far Side*, and the *Bloom County* Sunday spinoff *Outland*—were retired, and the online life of comics began to alter the playing field.

Now, the strip that cartoonists most often say is most worthy of inheriting the *Calvin and Hobbes* mantle is *Cul de Sac*.

"He actually sounds like the kids he draws in that amazing strip," Oliphant says. "What a gift that is, to write the way you talk. No strain, no presumption, just simple wry storytelling with characters you can care about and love. When did you last see that in comic strips?

"Not since Calvin and his tiger rode off into the sunset."

<p align="center">• • •</p>

Nick Galifianakis vividly remembers the moment he knew something was wrong with Thompson. He ran into him at a neighborhood diner and was alarmed. "He seemed to hold his arm stiff," says Galifianakis, who draws the cartoons for *The Post*'s advice column *Tell Me About It*, written by his ex-wife, Carolyn Hax. "As my dad and I walked away, we said to each other in Greek: 'Richard's had a stroke.' "

Galifianakis's bond with Thompson dates to the early '90s, when they admired each other's work and would discuss art for hours—Galifianakis, outgoing and garrulous; Thompson, quieter and wry. Soon, the two young couples, Nick and Carolyn, Richard and Amy, would talk till dawn. So, it was with heartfelt concern that Galifianakis arranged for Thompson to talk to a doctor in 2008. "I was having dinner at Nick's house," Thompson recounts. "His dad's girlfriend is an emergency-room physician who's an ace diagnostician. She asked me a string of questions and had me do some fairly simple things and said, 'That's neurological—probably Parkinson's.'

"I am ever in her debt."

That June, the diagnosis was confirmed.

"Getting diagnosed with this disease is to have your world struck by a meteor, transformed to ash in an instant of unexpected impact," says Peter Dunlap-Shohl, a former *Anchorage Daily News* political cartoonist who received a Parkinson's diagnosis in 2002, at 43.

Thompson, though, found a certain silver lining. "Strangely enough, I was kinda relieved," he says. "Just knowing what it is gave me some focus."

His wife was blind-sided. "He has never taken care of himself, so I thought it was exhaustion," Amy Thompson says of her reed-thin husband. "He had started to look like a zombie." It hadn't occurred to her that it could be something as serious as Parkinson's.

He shared the news with his fans a year later on his *Cul de Sac* blog:

"*For the last year or so, I've noticed a few odd symptoms: shakiness, hoarseness, silly walks, random clumsinesss and the like. So the other day, I went to see a neurologist and, after having me jump through hoops, stand on my head and juggle chain saws, he said I've got Parkinson's. It's a pain in the fundament and it slows me down, but it hasn't really affected my drawing hand at all and it's treatable.*"

"*And it could be a useful ploy in my ever-losing battle against deadlines.*"

<p style="text-align:center">• • •</p>

The first floor of Thompson's house brims with a spirit as irrepressible as Alice—this is the eclectic stuff of life that collects in a creative home. "Our house is full of costumes, props, and art supplies," Thompson says, "some of it is hard to explain or justify."

Some is his wife's work. She teaches theater at schools and in educational programs, including at the Folger Shakespeare Library. That explains the papier-mache donkey head on the dining room table, "*A Midsummer Night's Dream*," Amy says. (Richard's mother set them up after meeting Amy in a Gaithersburg, Maryland, bookstore. "Clearly we were meant for each other," Amy says.)

The couple's daughter Charlotte, 12, breezes in from school and starts telling her dad about her day as he pops his yellow pills for Parkinson's. Emma, 15, isn't home yet. Both daughters have asked whether they are the inspiration for Alice. "No *one* of anybody in my family has inspired any *one* of my characters," Thompson says. But "one of the things I was aware of when my daughters were younger was the process of socialization that all kids go through—it's the whole theme and point of childhood. To learn to get along and stand your ground and form relationships."

Watching his daughters play over the years does inform the strip's sidewalk truisms. "I know street names and addresses and all," Thompson says, "but the kids know where interesting piles of dirt are, or where the good sticks can be found or where a scary dog lives." As we head downstairs toward his basement studio, we're clearly entering the land of Petey, Thompson's most personal character. The 8-year-old is an aspiring cartoonist who abhors nature and sports. An introvert, he sits on his bed for hours devouring comic books and drawing his graphic novel, *Toad Zombies*.

"Petey is a truly original insight," Watterson says. "Wow, what a window into introversion and the childhood craving for stability, order, and control. Alice has no filters, and Petey is all filter."

Thompson acknowledges that *Cul de Sac* is infused with his own personality. "Alice has my obliviousness to what's going on," he says. "Petey is much closer to me, or at least the worst of me. He worries about dumb things; he's a perfectionist when it's unnecessary; he deals with the world best at a distance"—and keeps it at a distance by creating comics and shoe-box dioramas.

"One of my favorite things to do with him is to take him out of his comfort zone. Fish-out-of-water is always a great plot device—and Petey swims in a very small bowl."

A ground-level window lets a welcome shaft of sunlight into the peaceful studio, roughly 12 by 20 feet. It is a fertile place for creating worlds, for "complete disregard for time."

Along one wall are shelves of CDs. While he draws, Thompson listens to Brahms—the favorite composer of late *Peanuts* creator Charles Schulz, too. Propped against another wall is a banjo; the shelves above it burst with comic inspiration. Searle. Oliphant. Watterson. Herblock. Herriman. *Pogo*. "If I stare at these too long," says Thompson, smiling mischievously, "I don't get any work done."

As Thompson wields his trusty Hunt 101 Imperial nib, out of his still-sure hand and mind flow inspiration. "The ideas are a continuous process," Thompson says. "I usually feel like it's going on in the back of my head most of the time. The way I've set up the strip, with a lot of small gags and some slight forward momentum in little arcs, means that ideas aren't hard to come by.

"Ideas are easy. Knowing what to do with them is hard."

• • •

At Johns Hopkins—the Baltimore hospital where Thompson was born and where both his parents once worked administrative jobs—researchers such as Ray Dorsey help lead the fight against Parkinson's.

One million Americans have the disease, according to the hospital's Parkinson's Disease and Movement Disorders Center, which says that number is expected to triple in the next 50 years as the U.S. population ages. Symptoms can include tremors, rigidity, difficulty with walking or balance, and a slowing of movement. Plus, "As many as 40 percent of individuals will have depression, which can precede the motor symptoms," says Dorsey, the center's director.

The average age people experience symptoms is 60; only 5 percent to 10 percent have symptoms before 40. Thompson says he experienced his symptoms "for years" before his diagnosis at 50.

Symptoms develop when dopamine depletion approaches 80 percent, researchers say. But much about the disease remains mysterious. Dopamine was first identified as an independent neurotransmitter in the nervous system in 1957—the year Thompson was born. A decade later, a high-dose regimen of a drug called levodopa was introduced as a treatment for Parkinson's.

"The advance with levodopa was revolutionary," says Todd Sherer, chief program officer for the Michael J. Fox Foundation for Parkinson's Research. But "these treatments are only effective for a period of time."

Thompson takes the drug four times a day. When the medicine loses its effectiveness, the next step could be deep-brain stimulation. "It's almost laughably crude," says Thompson with characteristic humor. "They put an electrode deep in your head and turn it on, and boom! You're good to go again."

He is encouraged that "researchers have found a treatment that halts the progress of Parkinson's disease in mice." Then he has his own special treatment: "Daydreaming," he says. It has "gotten me through everything else so far."

• • •

The real *Cul de Sac* is a leafy, loping beauty of a street, still a testament to a past generation's hopes and modesty. It sits in the Maryland neighborhood of Montgomery Village, on Judge Place immediately past Ironhorse—a name that harks back to Lou "Iron Horse" Gehrig, the great Yankees ballplayer whose career was cut short by the neurodegenerative disease nicknamed for him.

Judge Place is one of three cul-de-sacs from Thompson's childhood, the one he would live on the longest and where his father, Richard Sr., 88, has long resided.

Parked in front of the elder Richard's bone-white, two-story house is a green Ford Mustang that easily would have fit in on the cul-de-sac in the early '70s, back when Richard Jr. was "the kid who draws" as well as "the kid who sucks at sports." The Mustang has been rebuilt by Tim Thompson, Richard's kid brother by seven years and a master sound designer at Washington's Arena Stage.

The cartoonist has fond memories of this cul-de-sac. It was a welcoming place for a young family of four. Richard Thompson Sr. and Anne Whitt Thompson worked various bureaucratic jobs, often for government agencies. They were together nearly a half-century, until her death in 1996. Like them, the Otterloop parents embody understanding, security, and stability.

Anne Whitt Thompson's childhood, though, was starkly different. In a 1982 memoir, she wrote the story of her painful voyage through a string of Charlotte area orphanages after age 6, when her mother died and her grieving father lost custody of his children. The book, titled *The Suitcases: Three Orphaned Sisters in the Great Depression in the South*, begins with Ephesians 4:14: "Children, tossed to and fro, and carried about with every wind . . . "

On the book's cover is an especially poignant illustration by Thompson, drawn when he was in his early 20s, fresh off studying art at Montgomery College. In tenderly rendered pencil-work is a Raggedy Ann leaning against two small suitcases. There's an open door, a threshold into a world of loss and uncertainty.

More Thompson illustrations run throughout the book—three young sisters playing, or listening, or standing atop a slide. The images have an undeniable gravity, reflecting moments of childhood sweetness, yet also a grim foreboding.

"I admired her for surviving a childhood out of Dickens so gracefully," Thompson says of his mother, "emerging not just whole but eminently sane."

Thompson says his dry sense of humor is much like his dad's, but "I'd hope my natural insight into people was as acute as my mom's."

• • •

As Richard Thompson takes his small yellow pills, the question lingers: Is the cartoonist hopeful that science will find a cure for Parkinson's in his lifetime? Thompson is encouraged, he says, that "researchers have found a treatment that halts the progress of Parkinson's disease in mice."

Among Parkinson's scientists and patients, the responses are as individualistic as the treatments themselves.

Dorsey, the Johns Hopkins director, says his work focuses on reducing the burdens and barriers of the disease. The Michael J. Fox Foundation, by comparison, states that a goal of its research is to find a cure. "I guess I'm more optimistic than most folks that within my lifetime, there *will* be a cure," says the Fox Foundation's Sherer, who is 38. "I've been in Parkinson's research for 15 years, and even in that time period, there's been a total refocus and renewed energy in Parkinson's based on increased information," continues Sherer, citing developing technologies, new genetic studies, and the influx of researchers into his field.

Dunlap-Shohl, the Alaska artist, speaks from the vantage point of having had the disease for nearly a decade. "In 2002, when I was diagnosed, the standard line was that a cure within 10 years was in our grasp. This is not the standard line anymore," says the cartoonist, who notes that his symptoms compelled him to learn to draw with an electronic pad. The disease is "much less easy to understand than we thought then. At the same time, the tools at our disposal to unravel this complexity are the best we've ever had, and improving all the time."

Still, Dunlap-Shohl says: "Parkinson's disease is hellishly complex."

• • •

In June 2008, Chris Sparks headed to the Heroes Convention in Charlotte looking to geek out to a world of comic-book superheroes. What he found instead, he says, was an inspiring paladin and friend in Thompson.

It was the same month Thompson's illness was confirmed. That June would continue to present profoundly life-altering turns.

"I was laughing and snorting so hard at one strip, I had to buy it," says Sparks, an Asheville, N.C., print and Web designer who was riffling through *Cul de Sac* originals.

He and Thompson stayed in touch, a friendship that led to Sparks's design of CuldeSacArt.com. Not long after, Sparks learned of Thompson's illness. His wife, Jennifer, bought him a book by Michael J. Fox about the actor's struggle with the disease. "I wasn't even done with the book when I had my idea."

With Thompson's blessing, Sparks launched a Parkinson's fundraising effort called Team Cul de Sac, reaching out to Thompson's syndicate and to Team Fox, the grass-roots fundraising arm of the Michael J. Fox Foundation. Their plan: Invite cartoonists to create art using *Cul de Sac* characters for a book and auction. Their goal was to raise $250,000. Sparks, comics blogger Mike Rhode, and former *Nickelodeon Magazine* editor Chris Duffy helped Thompson nail down the book's concept: To ask creators to use *Cul de Sac* characters however they might.

Thompson's guiding words: "Please run with them; deconstruct them, parody them, confuse them, cubisize them, psychoanalyze them, draw them in your own strip, whatever tickles your fancy." By May 2011, more than 100 cartoonists had signed up. Work came in from such veterans as *Doonesbury*'s Garry Trudeau and *Garfield*'s Jim Davis and *For Better or For Worse*'s Lynn Johnston, from such Thompson peers as *Pearls Before Swine* creator Stephan Pastis and Politico cartoonist Matt Wuerker.

Watterson contributed an oil painting—one of his only public art in nearly 16 years. It's a soulful portrait of Petey, looking cartoon goofy yet hauntingly real. ("I was reluctant to goof around with Richard's creation, so I had trouble thinking of an approach that interested me until I got the idea of painting a portrait," Watterson says. "I thought it might be funny to paint Petey 'seriously,' as if this were the actual boy Richard hired as a model for his character.")

Even as Thompson jokes that he is a reluctant "poster child" for this Parkinson's project, he says he is overwhelmed by the outpouring of support. This is all much bigger than just him, he says, a lone cartoonist who can barely think about his next deadline, let alone his long-term expectations as an artist with Parkinson's. "I'm only a few weeks ahead, so thinking too far ahead is even harder for me," Thompson says.

"Especially these days where the whole cartoon business is teetering on a yawning chasm."

• • •

Walking around the 2010 NCS Reuben Awards in Jersey City, N.J., Richard Thompson fielded professional compliments from old-time cartoonists nearing 90, as well as young artists working on webcomics or with Pixar. Wearing a timeless tuxedo, Thompson was embodying both the past and future of newspaper comics.

Thompson is a true student of the art form whose work nods to such predecessors as Schulz and Winsor McCay, the creator of *Little Nemo in Slumberland*. "*Cul de Sac* is a throwback to the strips of yore," Universal Uclick's Salem says, "when character, artwork, and writing all benefitted from more space in newspapers and an avid readership."

That same talent also inspires such current colleagues as Pastis, who a decade ago launched *Pearls Before Swine* with United Media (a longtime syndication giant that was to shutter its Madison Avenue doors in July 2011—another sign of the industry's shifting sands). "Richard's the kind of cartoonist whose work you look at and say to yourself, 'I need to do better,' " says Pastis, who at the 2011 NCS ceremony was up against Thompson for the Reuben Award. (The third finalist was "Tangled" filmmaker Glen Keane of Disney; Thompson would take home the Reuben.)

Mike Peters, the Pulitzer-winning creator of *Mother Goose and Grimm*, says with a cartoonist's admiration: "There will be a group of us cartoonists at the Reubens who will be waiting for Richard to drop [a 2011 award], and when he does, we will all stomp on his hands."

All the professional bouquets, all the notecards of encouragement—it's tribute to a talent whose strip evokes the glory days of newspaper comics. An artist who, in depicting the quirky world of childhood, also paves the hopeful way for his profession.

"*Cul de Sac* may be the end of the road for syndicated newspaper strips," says Art Spiegelman, creator of the Pulitzer-winning graphic novel *Maus*. "But what a classy place to get turned around."

MICHAEL CAVNA is a writer, editor and artist at The Washington Post; *a recovering syndicated cartoonist, he writes* The Post's *daily* Comic Riffs *blog at washingtonpost.com/comicriffs. He can be reached at cavnam@washpost.com and twitter.com/comicriffs*

THE
EXHIBIT

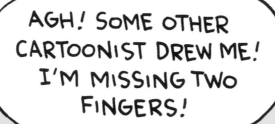

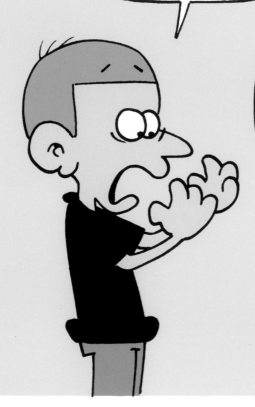

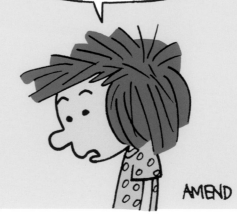

BILL AMEND

creator of *FoxTrot*

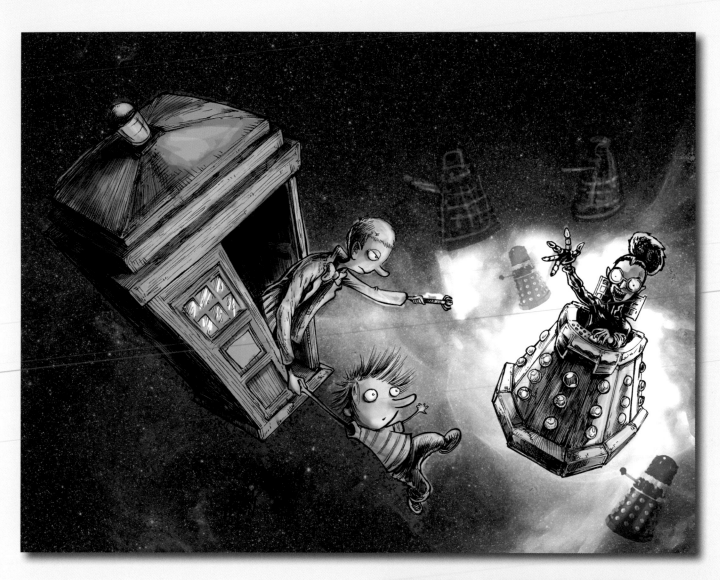

BRIAN ANDERSON

creator of *Dog Eat Doug*

Cul de Sac is that rarest of magic that sweeps you back in time, when you were eight years old and fell madly in love with comics for the first time. For that alone I will be forever grateful to the master magician, Richard Thompson.

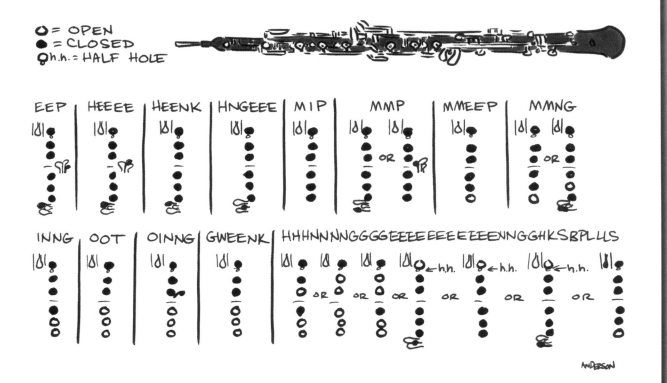

MARK ANDERSON

creator of *Andertoons*

Lots of people like to compare Richard and *Cul de Sac* to other cartoonists and other cartoons, but in my opinion, both the comic and its creator are quite simply incomparable.

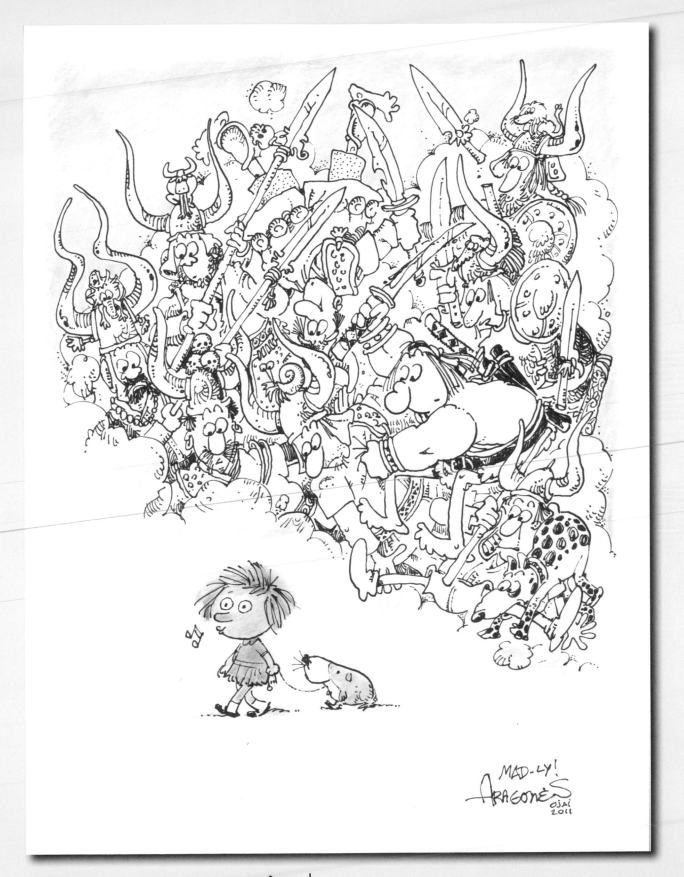

SERGIO ARAGONÉS

cartoonist, *MAD* magazine

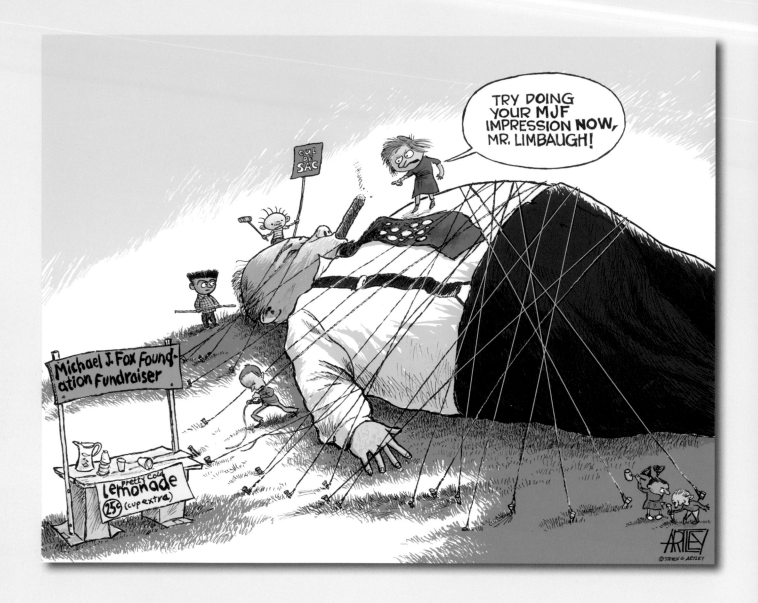

STEVEN ARTLEY

political cartoonist

I've had the pleasure of getting to know Richard Thompson over the last year or so. I took to him immediately, with his affable demeanor, soft-spoken manner, and sharp wit. Richard brings a dimension to *Cul de Sac* and a depth to the characters that leaves so many other comic-page features stuck at a dead end.

I have long been a staunch supporter of research to treat and cure degenerative diseases such as Alzheimer's and Parkinson's—and was outraged a few years back when Rush Limbaugh shamefully mocked Michael J. Fox's affliction. So, when the opportunity came up to draw something for the Team Cul de Sac project, my objective was clear. In "The Lilliputians of Cul de Sac," justice is aptly served to the neighborhood bully.

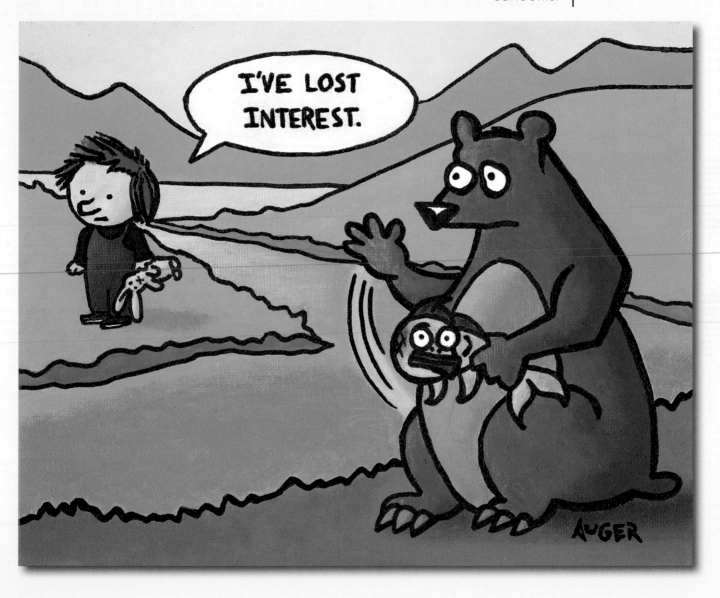

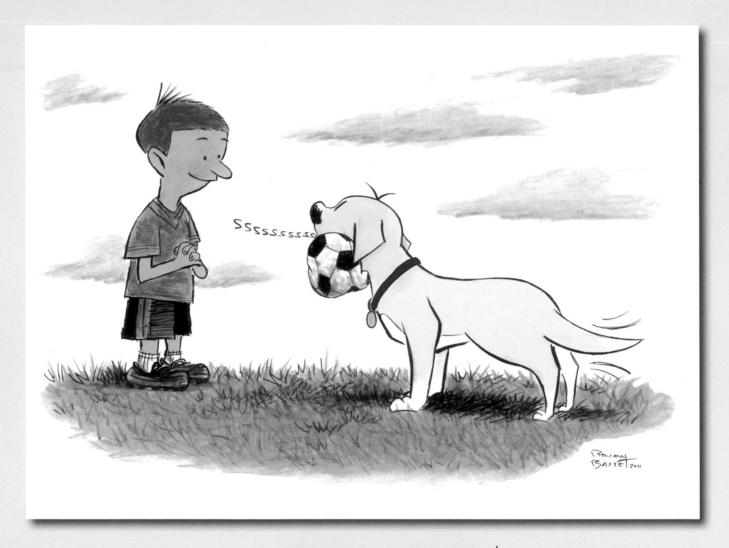

BRIAN BASSET

creator of *Adam@Home* and *Red and Rover*

As children, we are encouraged to color outside the lines. As adults, we are not.

Nobody today quite captures that freewheeling feeling of childhood and coloring outside the lines like Richard Thompson. *Cul de Sac* is a triumph of the human spirit refusing to grow up!

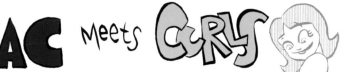

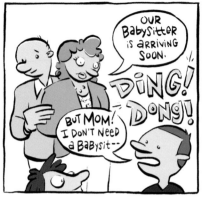
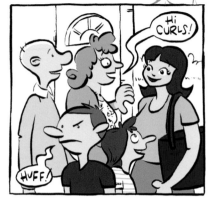
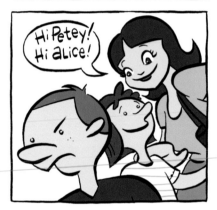
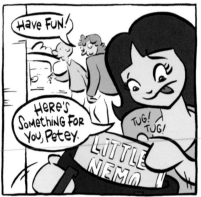
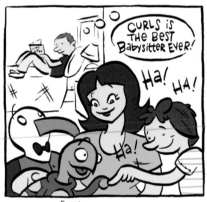

CAROLYN BELEFSKI

creator of *Curls*

For my Team Cul de Sac art, I wanted to create a story involving Richard's characters and my *Curls* character. I felt like the Otterloop parents needed to go on a date because they hardly have any time to themselves, so I wanted them to get away and introduce *Curls* to look after Alice and Petey. Richard Thompson is a brilliant cartoonist. I admire his skills very much, and I wish Team Cul de Sac the best of luck to raise money for Parkinson's research.

SANDRA BELL-LUNDY

creator of *Between Friends*

I wanted to contribute to Team Cul de Sac for two reasons. One was the opportunity to assist with fund-raising to support research in finding a cure for Parkinson's. The second was to support Richard personally. He's a gifted cartoonist, and a warm and wonderful person.

JEREMY BILLADEAU

creator of *Skipper*

"Only the most foolhardy of souls would contest to laughter as being the best medicine. However, no one can dispute the premiums one has to pay for its potential health benefits."

—Jeremy Billadeau

This is why I found myself both honored and humbled to lend this small prescription to such a great artist as Richard is, and to such a phenomenal cause that touches so many lives for the better. . . . and you can quote me on that, Chris.

JIM BORGMAN AND JERRY SCOTT

cocreators of *Zits*

I imagine Richard beginning each day with a big block of ink and then chipping away everything that isn't funny to look at.

—Jim Borgman

New comic strips are the best medicine for existing comics, especially when they're as good as *Cul de Sac*. Richard has walked in to the funny pages and quietly nudged the bar for writing and drawing upward. Thanks, pal.

—Jerry Scott

RUBEN BOLLING

creator of *Tom the Dancing Bug*

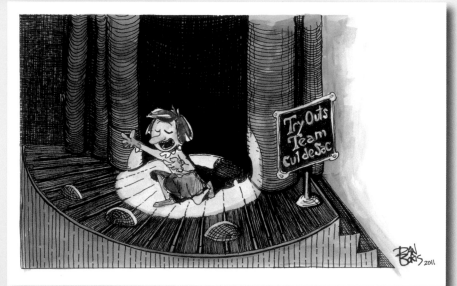

DANIEL BORIS

creator of *Hoxwinder Hall*

The reason I chose Alice as the subject for my illustration is because I see Alice as the heart of Richard Thompson's *Cul de Sac*. Alice is expressive and daring and full of energy and wonder. I could see her on a stage, in the spotlight, trying out to be a cast member. She'd do something spectacularly whimsical and unexpected. She would—of course—also get the part!

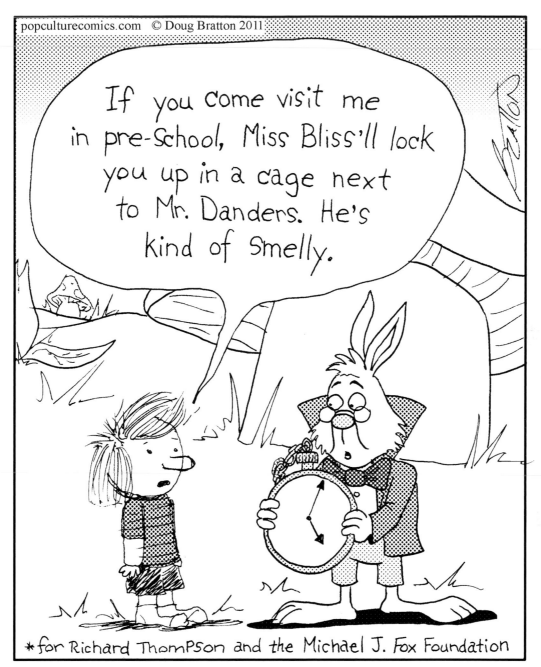

Alice in Wonderland

DOUG BRATTON

creator of *Pop Culture Shock Therapy*

Richard's work is just absolutely beautiful and unique. As a cartoonist, when I first saw *Cul de Sac*, I simultaneously wanted to give up and work harder. The magic that exists on the comics page is deeper because Richard puts ink to paper, and all of us who still believe in that magic owe him our gratitude.

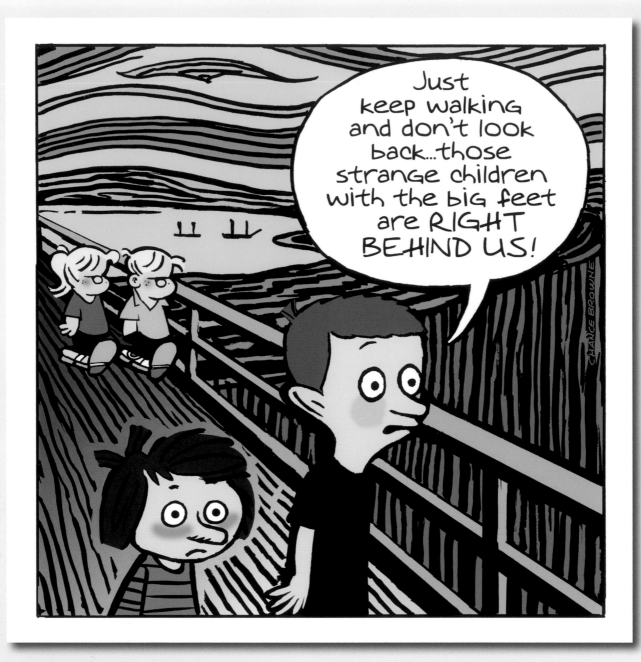

CHANCE BROWNE
AND BRIAN WALKER

creators of *Hi and Lois*

When I first discovered *Cul de Sac* in 2007, I immediately recognized it as one of those inspired comic strips that only came along about once a decade. I love Richard Thompson's quirky characters, scratchy drawings, and unique insights into the awkward process of growing up.

 Cul de Sac is a pleasure to read every day, and I look forward to many more years of following Richard's chronicle of life in a world composed entirely of lines, words, and a fertile imagination.

—Brian Walker

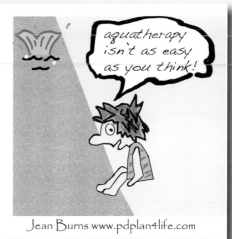

Jean Burns www.pdplan4life.com

JEAN BURNS

fan

TONY CARRILLO

creator of *F Minus*

I was lucky enough to meet Richard once. He had been described to me as a brawny bull of a man with a fiery temper, a wicked left hook, and a shock of wild green hair. Instead, I found him to be a gentle, humble soul; the type of man you'd trust to watch over your french fries while you go to the bathroom, which I did. And let me tell you something, when I returned two and a half hours later, I counted twenty-three french fries on my plate—two *more* than when I left. I still don't know how he did it, but I am in his debt.

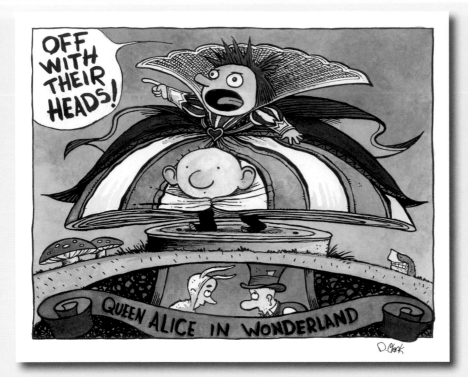

DAVID CLARK

cocreator of *Barney & Clyde*

MICHAEL COLE

Dragin Comics

Cul de Sac helped inspire me to pursue cartooning. I was honored to be given the chance to contribute to one of my favorite cartoonists.

TYSON COLE

creator of *The Deep End*

I think that when certain people face extreme difficulty in their lives, something amazing happens. I don't know if they actually change—or if something that is already inside of them surfaces—but either way, an almost superhuman strength reveals itself. They learn to face the problem with optimism and inspire everyone they come in contact with. Perhaps most surprisingly, they acquire a determination to help others. Richard Thompson is one of this type of people. A man named Raul, who I met while I was living in Chile, also afflicted with Parkinson's, was another. Those of us who have been fortunate enough to avoid trials like this up until now have a great deal that we can learn from these special people. We should have a little more gratitude for the things that are good in our lives. We should have a positive outlook, no matter how bad our current situation seems to be. Most of all, we should follow this great example and look for ways to help those in need. That, more than just about anything else, will benefit us all the most.

STEVE CONLEY

comic book illustrator

Richard Thompson's *Cul de Sac* is why I still buy a newspaper. His work is beautiful, genuinely funny, and has an honesty and charm, which makes me feel like I'm getting a deal by paying 75 cents for a printed edition of yesterday's news. They should rename the newspaper the *Washington Post Starring Cul de Sac*. They'd sell more copies, I'm sure of it!

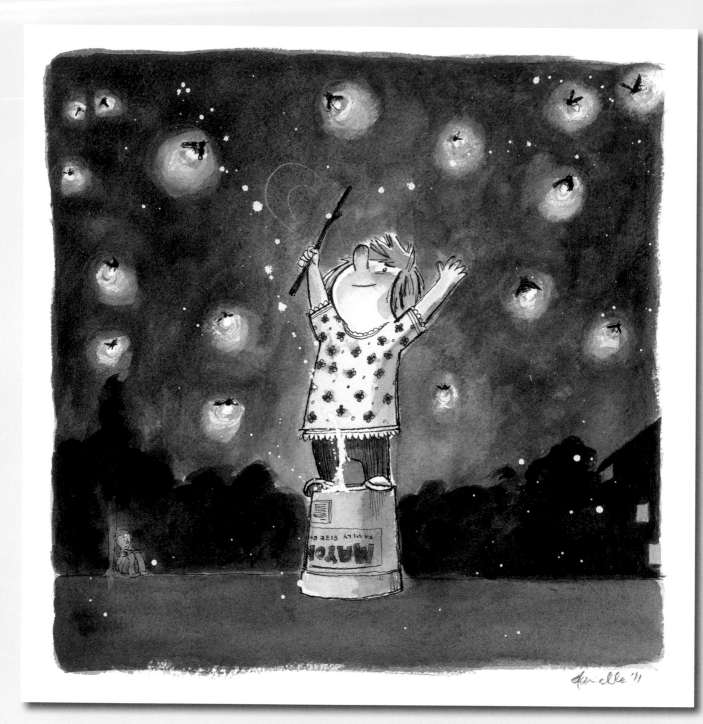

DANIELLE CORSETTO

creator of *Girls with Slingshots*

Richard's work made me fall in love with syndicated comics again. I like to pretend that Alice is what I was actually like when I was a kid (I wasn't nearly as cool).

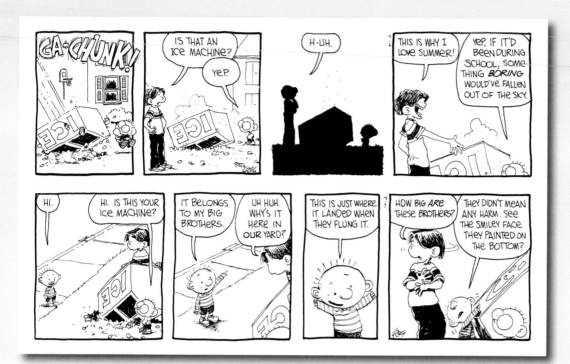

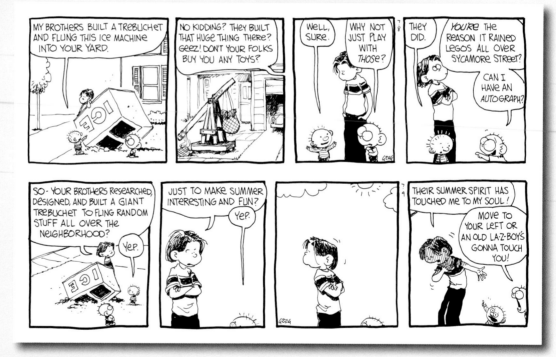

GREG CRAVENS

creator of *The Buckets*

Occasionally, a cartoonist will see someone else's comic strip for that day and say, "Man, that's great. I wish I had thought of that first."

Rarely, a cartoonist will see someone else's entire comic strip and say, "Wow, that's amazing. I wish I had thought of that first."

Richard's *Cul de Sac* is the next level up. Seeing it makes us say, "Nuts. I wish I was Richard."

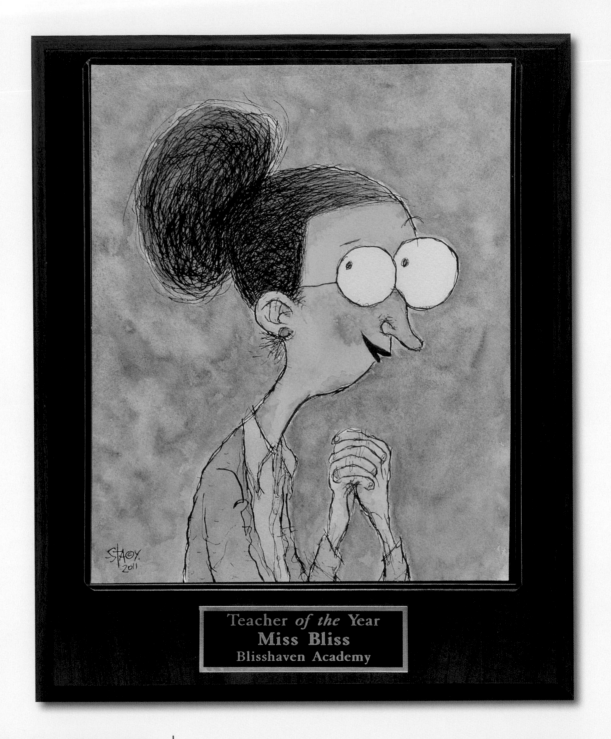

Teacher *of the* Year
Miss Bliss
Blisshaven Academy

STACY CURTIS

children's books illustrator

When Richard Thompson so deservedly won the Reuben Award for Outstanding Cartoonist of the Year from the National Cartoonists Society, I thought to myself, "You know who else deserves an award? Miss Bliss."

Despite being the only teacher at Blisshaven Academy, Miss Bliss deserves to be named Teacher of the Year for putting up with Alice Otterloop and her cohorts.

Congratulations, Richard, for creating a beautiful, well-written comic strip that makes hunting down a newspaper worth it, just to see *Cul de Sac* in its natural print form.

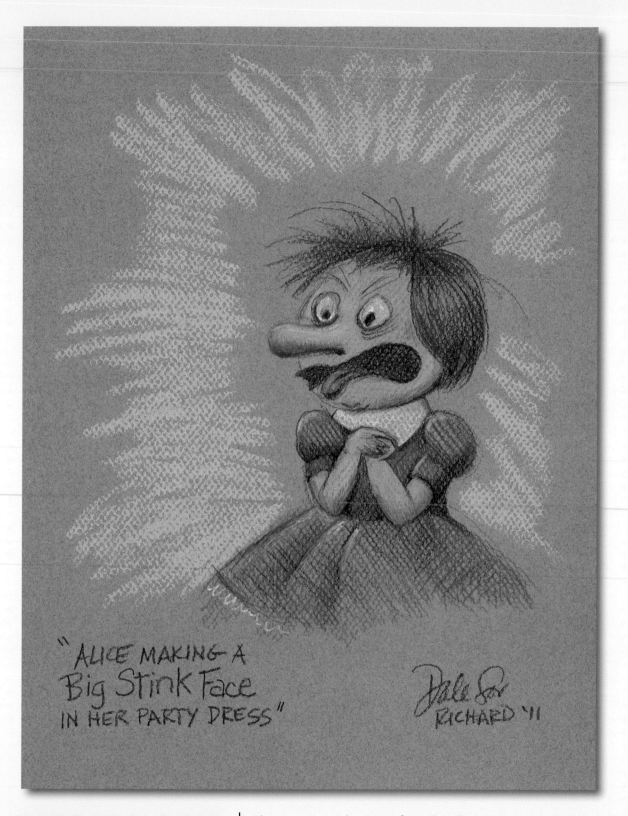

"ALICE MAKING A Big Stink Face IN HER PARTY DRESS"

Dale Sor RICHARD '11

BARBARA DALE

comic illustrator

There's never been a female character depicted in a comic that felt like me until Alice. Not Brenda Starr, not Cathy, not Blondie, Lois, Betty, Veronica, or Lucy. Most certainly not Wonder Woman. Thank you, Richard, for giving my sneaky thoughts an avatar. And such a well-drawn, expressive avatar at that.

DEREK AND NIKKI DAVIS

cartoonists

Both my wife and I are cancer survivors, and we know how it is to live with a debilitating disease. Our hope is that with this book, money will be available for research to find a cure for Parkinson's disease.

JIM DAVIS
creator of *Garfield*

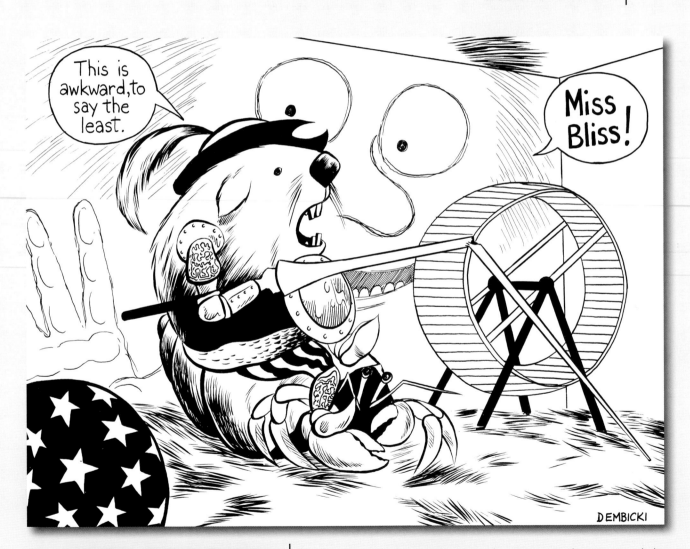

MATT DEMBICKI
illustrator and cartoonist

It's been a long time since I have eagerly awaited the next morning to read the subsequent installment of a comic strip. *Cul de Sac* has reinvigorated the excitement I had as a kid for the magic of comic strips.

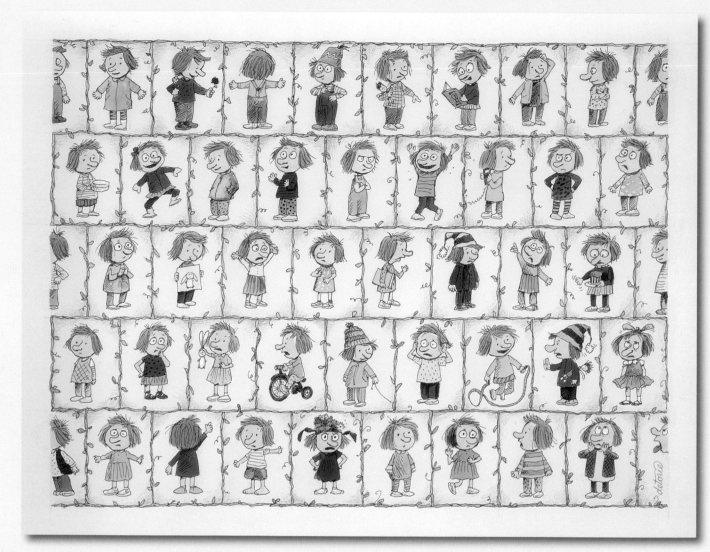

RICK DETORIE

author of *The Accidental Genius of Weasel High*

Richard Thompson draws funny.

By that I mean his drawings, with their loopy lines, scritchy scratchings, and omnifarious orbs, coalesce to form characters whose faces seem to have been channeled from ancient Inuit totems (or the lavatory wall of the Kerrville, Texas, Dairy Queen). They're stand-alone funny. You don't even have to absorb the gag to be tickled silly.

And it's just so damn wonderful.

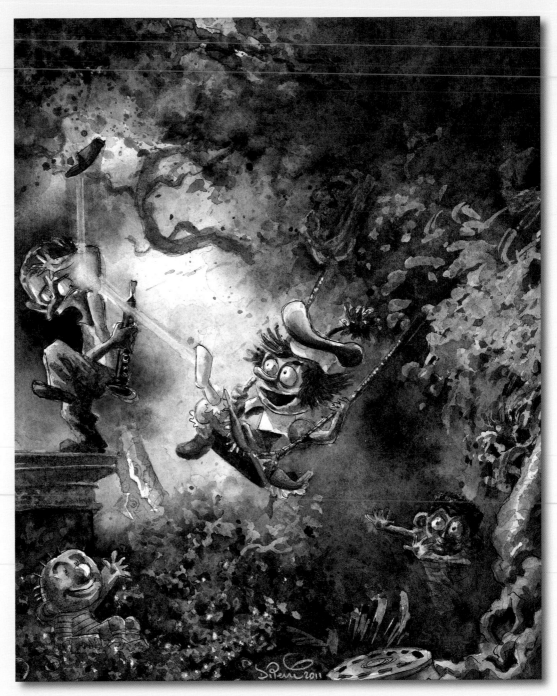

NATHAN DIPERRI

artist, illustrator, cartoonist

Richard Thompson's *Cul de Sac* is a charming and memorable experience for anyone who has ever been a child. It offers a world in which there is a tangible sense of optimism colored with brilliant humor and honest observation. Jean-Honoré Fragonard's 18th-century oil painting *The Swing* is one of the quintessential romantic works of art. Both *The Swing* and *Cul de Sac* are celebrations of youth and snapshots of fleeting beauty. In art, both are eternal, and it seemed fitting to place Mr. Thompson's artistic contributions in context of their magnitude on the cartoon industry.

As the enduring power of works from the old fine-arts masters have stood the test of time, *Cul de Sac* will too prove to be everlasting.

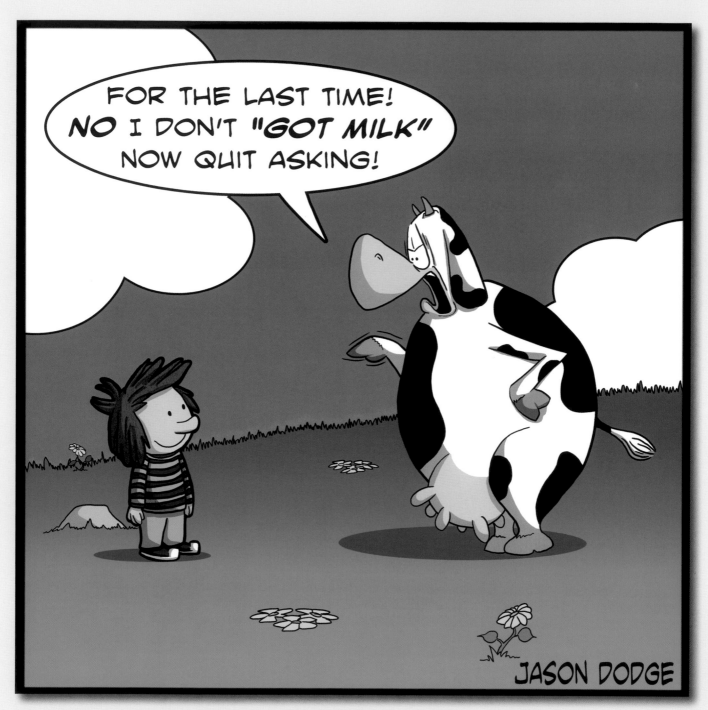

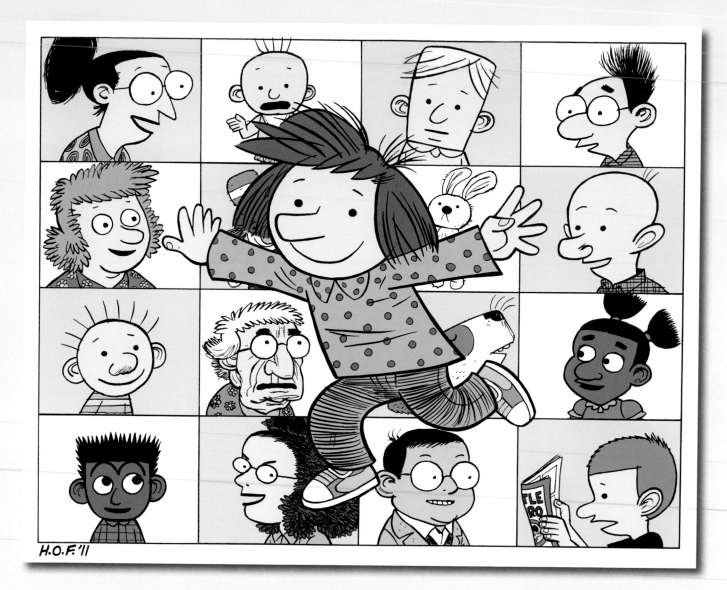

EVAN DORKIN

creator of *Milk and Cheese*

I absolutely adore *Cul de Sac*, which is something I wouldn't normally say about anything in this world other than my six-year-old daughter (who also happens to be a *Cul de Sac* fan; she requested I put the Uh-Oh Baby in my drawing). For me, the strip holds its own against the all-time greats. It's funny as hell, beautifully drawn, imaginative, and full of wry observations about life and those who live it. I'm in awe of Richard's work, we are lucky to have him, and it was my great pleasure to contribute to this celebration of his work and the worthy cause it benefits.

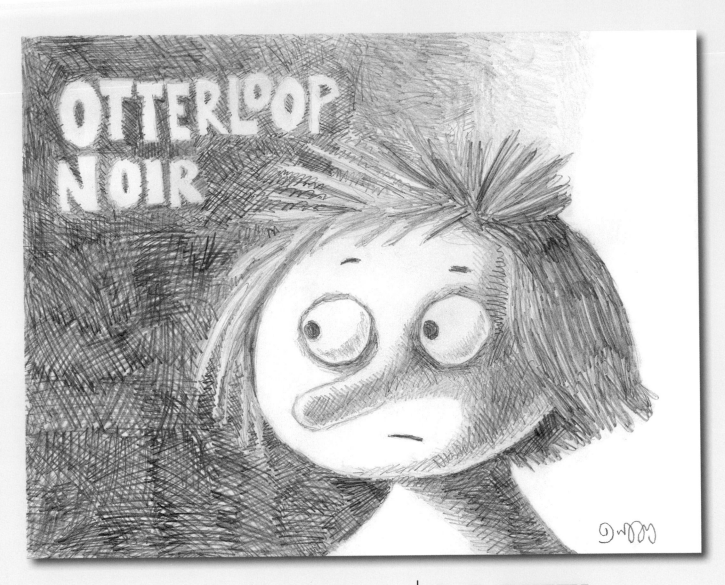

J. C. DUFFY
creator of *The Fusco Brothers*

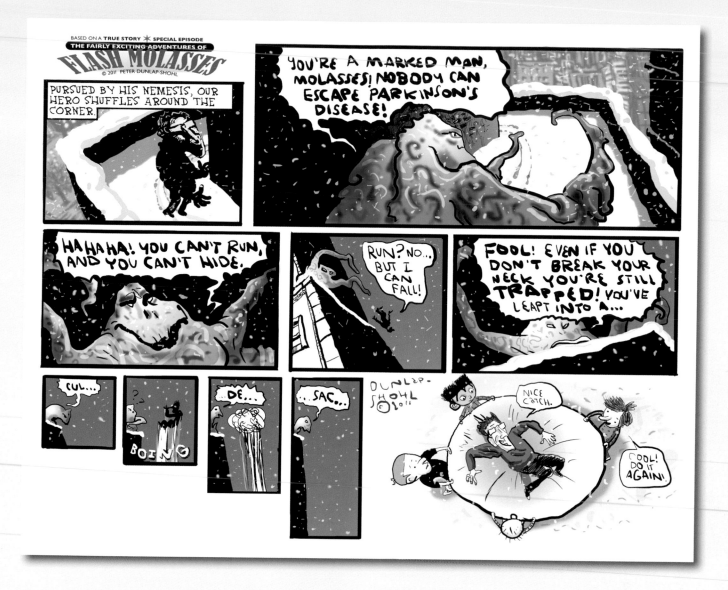

PETER DUNLAP-SHOHL

cartoonist

I was diagnosed in 2002, at the age of 43, with Parkinson's disease. I knew so little about the disease that all I could focus on were the words "progressive, incurable, and disabling."

Parkinson's disease is a disruption of your ability to move properly, and it steals your ability to perform the simplest task. It threatened my longest-held sense of who I am and wanted to be, a cartoonist. I had been editorial cartoonist for the *Anchorage Daily News* for twenty years, and drawing since I was six. To not draw was to not be myself. Drawing is all about solving problems with your limited abilities. PD is all about supplying problems and limits. One of my biggest battles is to draw without pain. PD causes stiffness in your muscles that can lead to all kinds of ergonomic problems. As you find new ways to solve problems, Parkinson's finds new ways to screw you up, so it's a constant test of creativity on top of the normal creative demands.

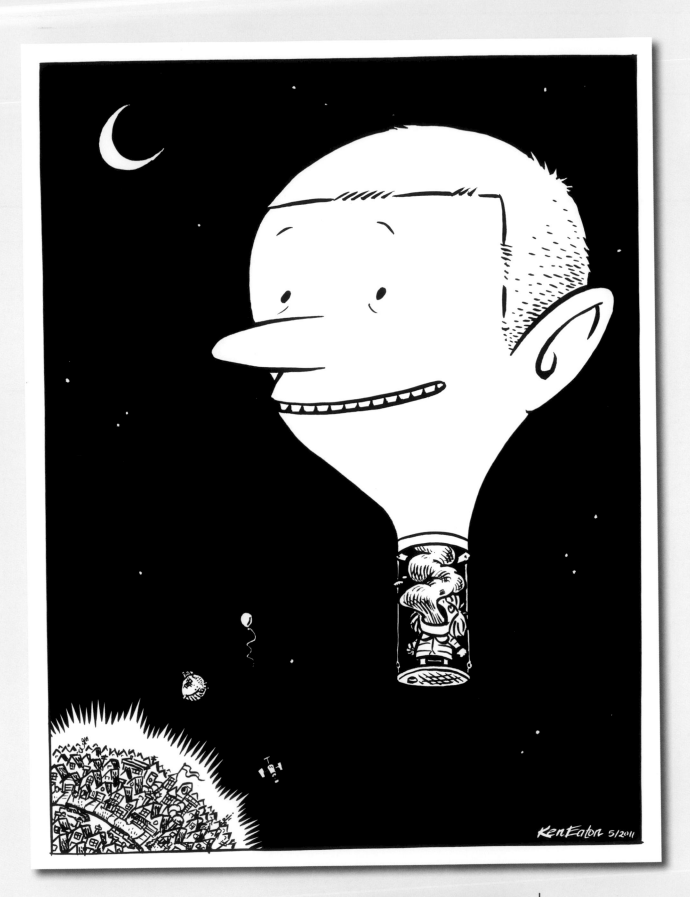

KEN EATON
illustrator

JAN ELIOT

creator of *Stone Soup*

Richard is the sweetest cartoonist on the planet, and he creates a wonderful, original comic strip. I really admire him!

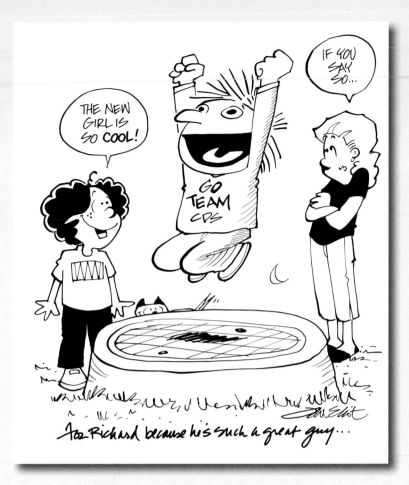

GREG EVANS

creator of *Luann*

Once in a blue moon, just when it seems like there's nothing new to be done on the comic page and every possible style of drawing and writing has been exhausted, a cartoonist comes along who makes us all stop, put down our pens, and go, "Dang! I wish I'd done that." We all deeply admire Richard for his unique talent. If he wasn't such an incredibly humble guy who's impossible not to love, we'd hate him.

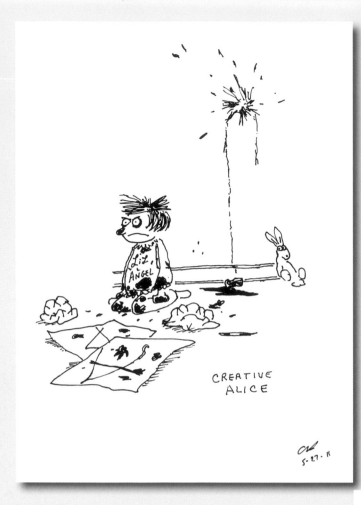

CREATIVE
ALICE

CRAIG FAUST

fan

RON FERDINAND

cartoonist, *Dennis the Menace*

With *very* funny writing and *really* great drawings, *Cul de Sac* has everything you could ask for in a comic strip, and *then* some.

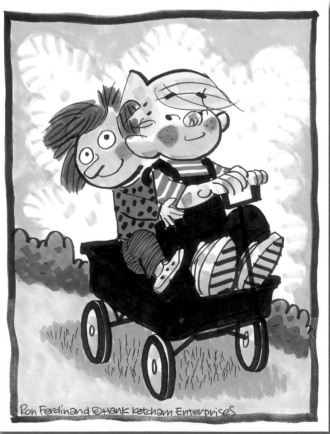

Ron Ferdinand ©Hank Ketcham Enterprises

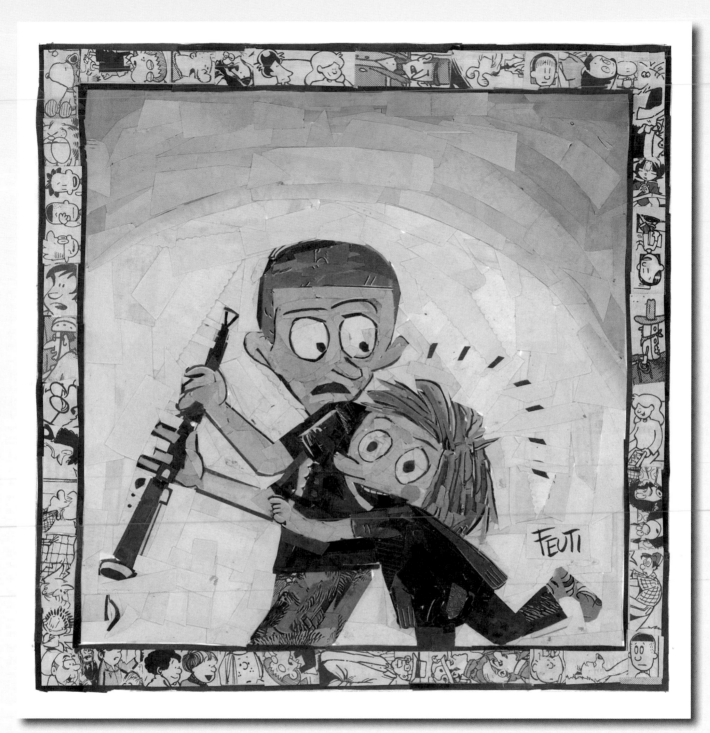

NORM FEUTI

creator of *Retail*

I created this collage from Sunday comics newsprint because I wanted to create an homage to Richard's work out of the very media he enriches every day. The level of craft Richard brings to *Cul De Sac* is a rarity in comics today. Thanks to Richard, the funny pages are a richer place to visit.

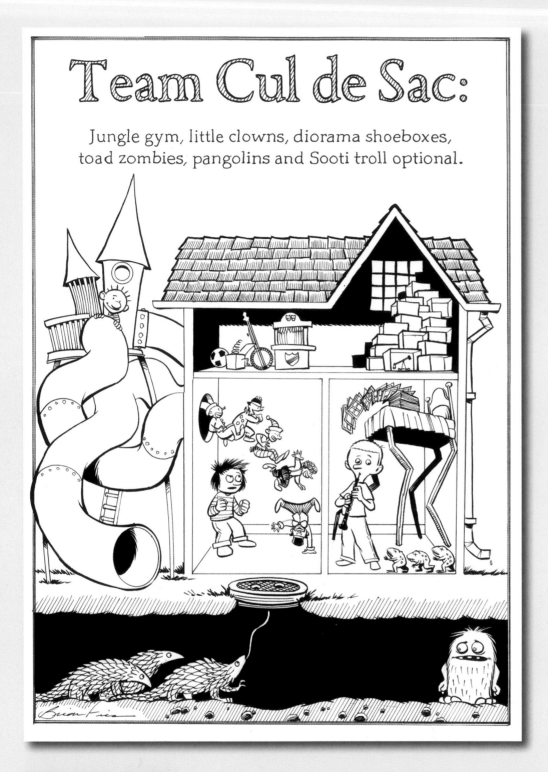

Team Cul de Sac:

Jungle gym, little clowns, diorama shoeboxes, toad zombies, pangolins and Sooti troll optional.

BRIAN FIES

author of *Mom's Cancer*

Cartoons are a unique medium that can inform and touch people in ways that no other medium can. The *best* cartoonists, like Richard Thompson, create words and pictures that tap directly into their readers' brains. Having explored the seam where art meets medical science a bit myself, I was eager to follow it in a different direction and join Team Cul de Sac.

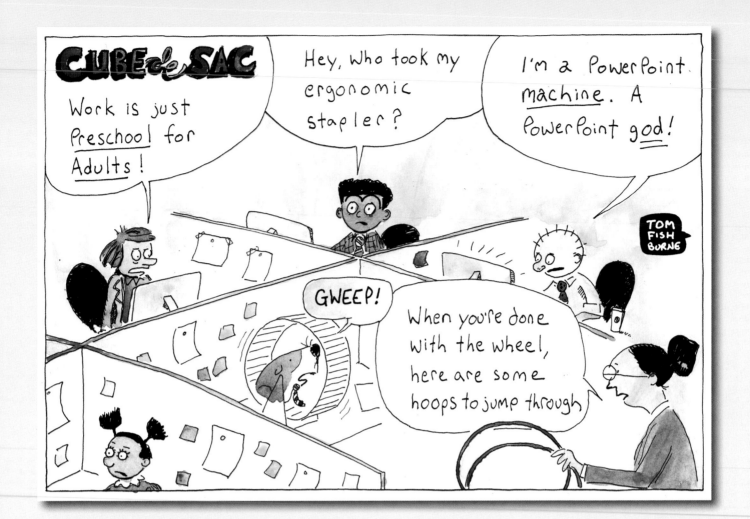

TOM FISHBURNE

cartoonist

I am a huge fan of Richard's work and approached him sheepishly at the National Cartoonists Society meeting last year. He generously took a few minutes to talk with me about cartooning, and it struck me how humble he was in spite of his tremendous talent. It is so fitting that he would turn his experience with Parkinson's into an opportunity to raise awareness of the broader cause. I wanted to help any way I could.

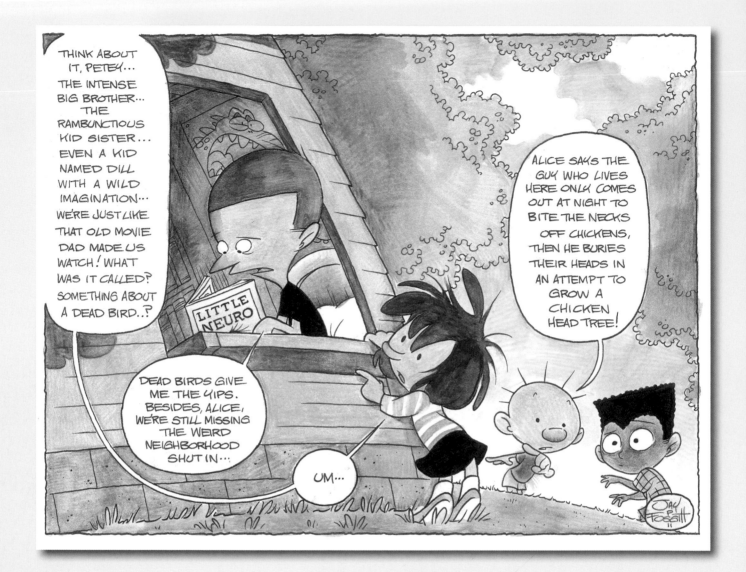

JAY FOSGITT

graphic novelist

I'm a big fan of Richard Thompson's comic strip, *Cul de Sac*, and also a big fan of Harper Lee's book, *To Kill A Mockingbird*. When I first read Richard's comic, I was overwhelmed by the wonderful similarities of the two works, from characters to themes and the shared ideals of hope and perseverance. Richard goes further to carry these strengths into his personal life, which not only inspires me as a cartoonist but as a person.

NICK GALIFIANAKIS

cartoonist

The Searleing of Richard Thompson, or *The Blessing of the Heir*

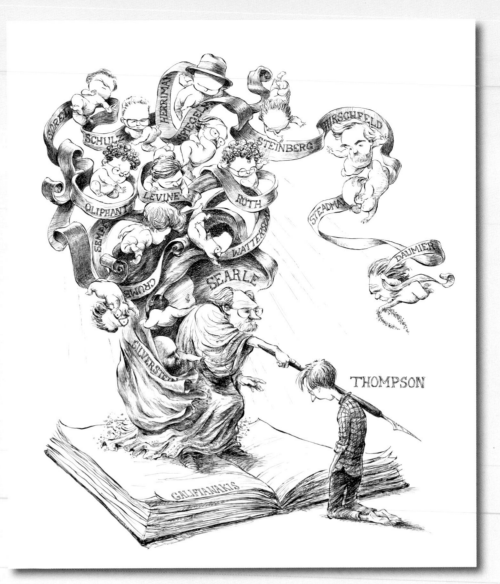

There are very few geniuses in the world. The rest of us can aspire only to recognize one, and I've had the rare privilege of doing so in my longtime friend. For twenty-five years, I have been in Richard Thompson's studio to witness his evolution, from lavish pencil drawings to rich oil caricatures through to his brilliant comic strip.

His depth of talent, diversity of vision, and unique interpretation of the world around him are so rare that I can only think of one other artist whom I would equate with Richard—the great Ronald Searle.

It's not my intention to diminish other talented and important cartoonists, though contemporary greats already agree that Thompson's work merits special distinction. As such, my illustration depicts the acknowledgment of his place in the history of what we do: Surrounded by a pantheon of cartoonist gods, Searle blesses his heir.

Of course, there are giants of cartooning missing. Where are MacNelly and Nast? Trudeau, Breathed, Chast, or Larson? The virtuoso Chuck Jones? They're all there, and many others, represented by the anonymous cherub clinging to the master's shoulder.

And so the mantle passes from Searle to Thompson . . . my grandiose tribute to the humblest of men.

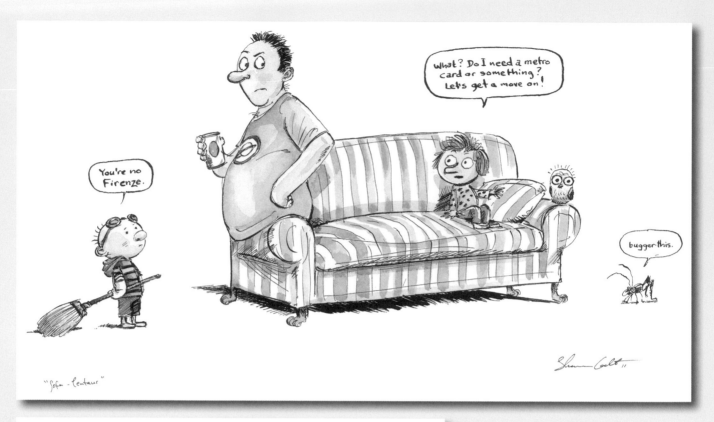

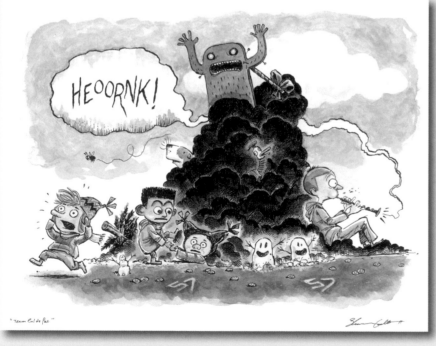

S. L. GALLANT

graphic novelist

Richard isn't an imposing figure, and his art is deceptive in that same way. Just as he will lull you into a false sense of safety and then zap you with a verbal zinger, his art will lure you in like a maze, and you'll be trapped before you know it. Once inside the drawing, you start to notice the structure, and that's when the genius comes out. You begin to see it like a spider's web, every line carefully placed, with nothing random about it. Once you notice that, it's too late; he has you. Sadly, you don't mind being caught up in Richard's crazy, insightful, funny world, for, of all the places I've seen, in some quirky way his makes more sense.

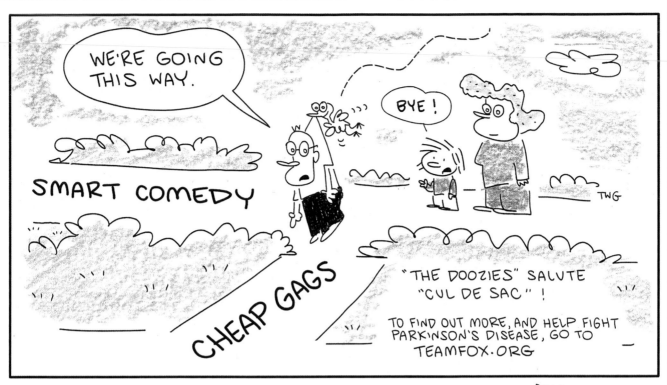

TOM GAMMILL

creator of *The Doozies*

When *The Doozies* started on GoComics, Richard was one of the first celebrity cartoonists to contact me. I was thrilled that he read the strip and said nice things about it, even if he was lying.

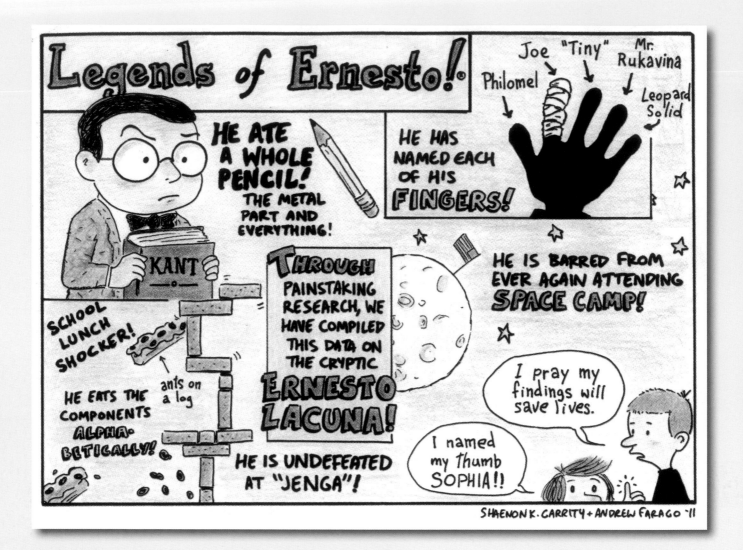

SHAENON K. GARRITY AND

cocreator of *Skin Horse*

ANDREW FARAGO

author of *The Looney Tunes Treasury*

Richard's one of the greatest cartoonists of his era, and before long, he'll be on the short list of the all-time greats. He's even funnier and more charming in person than he is on paper, if you can believe that. I contributed to Team Cul de Sac mostly for selfish reasons, in that I'd like to see Richard cartooning for another hundred years.

—Andrew Farago

Cul de Sac won me over from the first strip, and I couldn't pass up an opportunity to draw the characters. In particular, I wanted to delve into the mystery of Petey's possibly imaginary friend/ supervillain Ernesto Lacuna. Thanks, Richard, for giving Andrew and me that chance!

—Shaenon K. Garrity

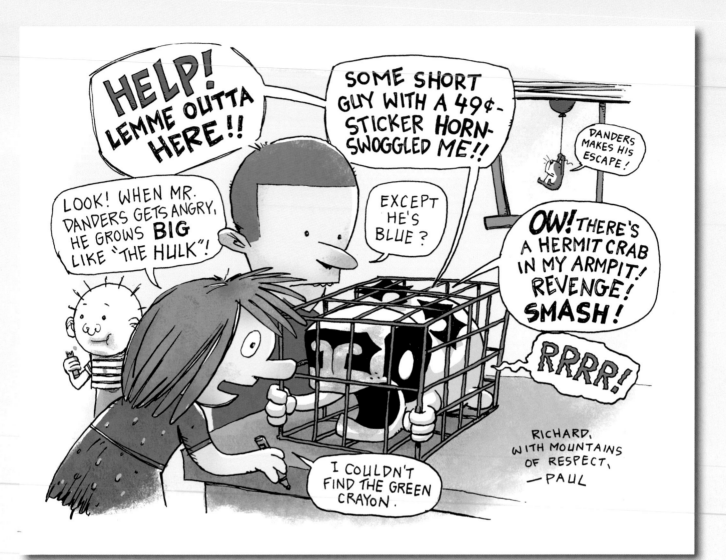

PAUL GILLIGAN

creator of *Pooch Café*

When I was a kid, I used to lie on the living room carpet with the comics page and get inspired. I knew what I wanted to be. I went to my room and started drawing. As time went by, I drew more and laid on the floor less. Most of my inspirational heroes of the comics page stopped producing, and I had deadlines; cartooning had become my job. The moment I saw Richard's work, I was back on the living room carpet again. He's the reason cartoonists cartoon. Thanks for that, Richard.

CAANAN GRALL

cartoonist

If helping raise money to find a cure for Parkinson's means helping Mr. Thompson do *Cul de Sac* for a longer time than he may have right now, then I am on board with that. Then, once that disease is taken care of with truly stranger-than-fiction modern science, and there's a fund-raiser for eternal youth (or cloning) so he can do it forever, I will be here for that, too.

DAWN GRIFFIN

creator of *Zorphbert and Fred*

BRAD GUIGAR

creator of *Evil Inc.*

I was determined to be unimpressed when I picked up *Shapes and Colors,* but three strips in, I became an admirer. I think very few people compare to Richard's ability to convey the complex mix of delight, terror, and confusion that is childhood. From his loose, sketchy lines to his ability to write believable, intriguing characters, Richard is a master of his craft.

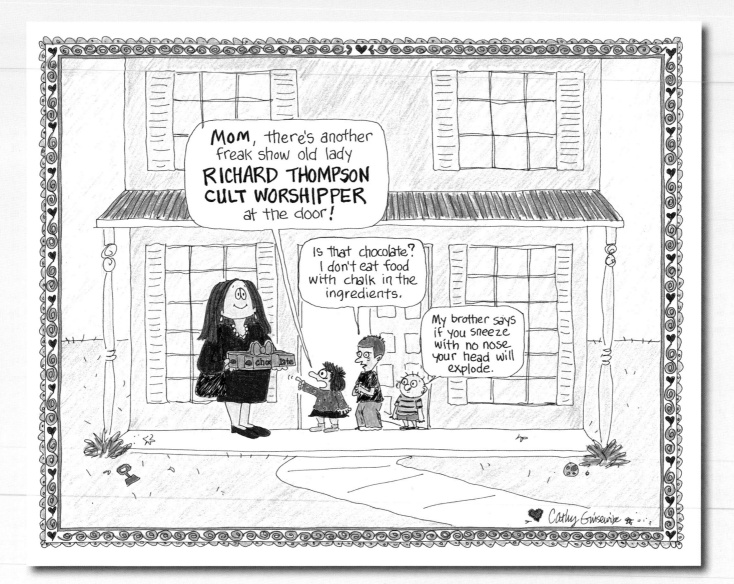

CATHY GUISEWITE
creator of *Cathy*

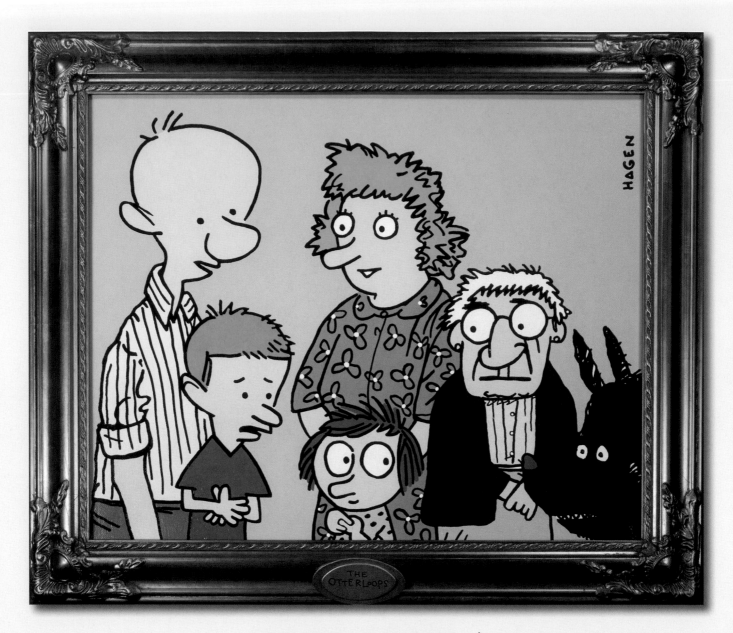

DAVID HAGEN

illustrator

Richard's studio is a narrow little rectangular room in the basement of a charming house, and we laughed about how cartoonists like their little, dark cubbyholes surrounded by things that bring them comfort: books, music, and art. Richard has an impressive classical-music collection in his Art Cave, and I can imagine him crosshatching away to some staccato piece. He's truly a maestro when the ink flies.

ALEX HALLATT

creator of *Arctic Circle*

Arctic Circle, a comic strip syndicated by King Features, was launched two weeks before the brilliant *Cul de Sac . . .* guh.

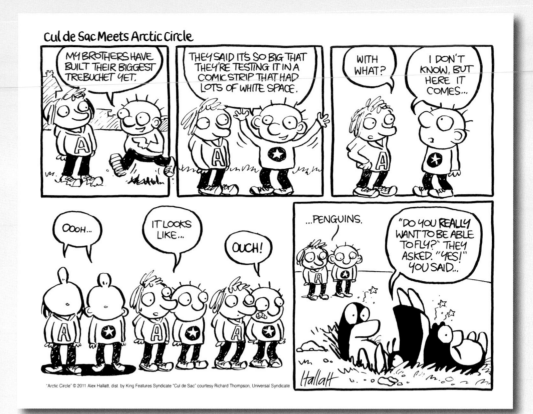

JOHN HAMBROCK

creator of *The Brilliant Mind of Edison Lee*

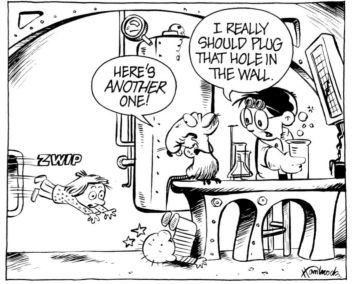

FM HANSEN

cartoonist and illustrator

I love humor that speaks to the human condition like Richard's work, Schulz, Thurber, Feiffer, and many others. Each of these artists had the ability to say so much with so little. Their humor invited you in and sandwiched truth together with humor and spoke directly to the reader, allowing you to laugh at yourself and the world.

DUSTIN HARBIN

cartoonist and illustrator

Cul de Sac, if you've never read it, is one of the best newspaper strips ever, and that, my dears, is no exaggeration. It's graceful but idiosyncratic, never in a hurry but never boring, playfully drawn but rooted in deep cartooning know-how. Richard Thompson really is one of the most influential cartoonists of his (or my) generation. Parkinson's is a degenerative illness that's within our power to cure; for those of us who aren't doctors or researchers and can't help directly, being able to donate money to research and treatment is not only an option but a necessity.

ROB HARRELL

creator of *Big Top*

ROB HATEM

artist

Richard Thompson is a master inker and thinker, and I love his work. I can't think of any artist whose work has given me more joy. And I was thrilled when he started *Cul de Sac*. Obsessively, I did four illustrations, all born of my simple-headed observation of Beni's unibrow—he has a sideways *3*-shaped eyebrow that reminds me of Frida Kahlo's self-portraits. So I drew her as his teacher, lording over him with a yardstick ("the law of 3 feet"). Then, as the penmanship instructor, overseeing him practice his *3*s. Then, as a writing instructor, with an assignment to write about famous trios (Marx Brothers, Stooges). Afterwards, I was happy to notice this April 14 strip that united Beni and the number 3.

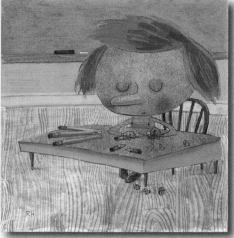

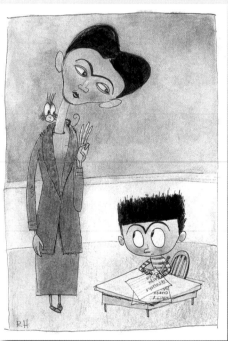

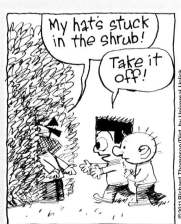

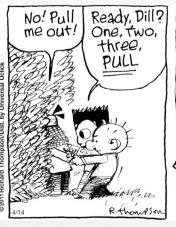

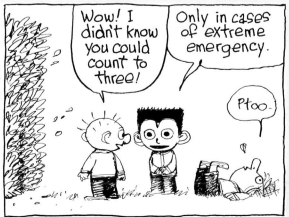

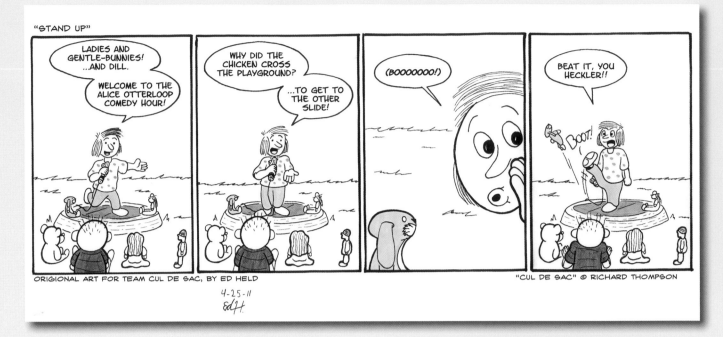

"CUL DE SAC" © RICHARD THOMPSON

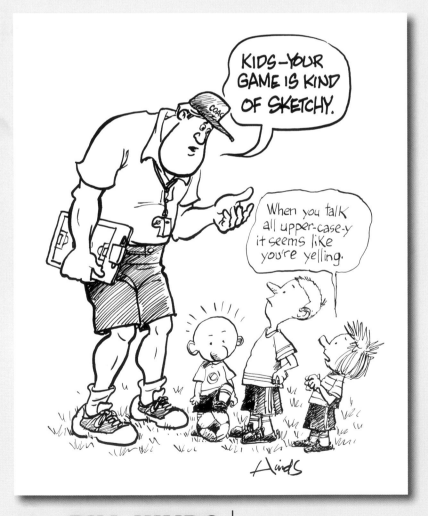

EDWARD HELD

cartoonist

I have not had the pleasure of meeting Richard Thompson. This is something I hope to correct one day. I first discovered Mr. Thompson's comic strip after hearing an interview he did on Tall Tale Radio with Tom Racine. I read a few *Cul de Sac* comic strips online and was immediately hooked. Thompson's world is filled with unforgettable characters and situations, and is a delight to read every day!

BILL HINDS

cocreator of *Tank McNamara*

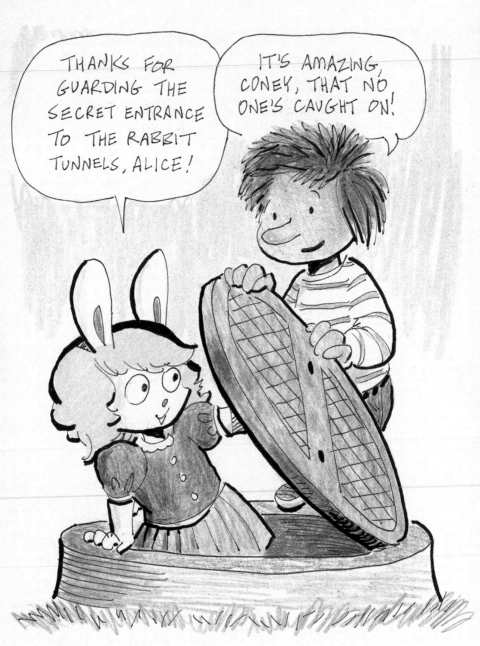

BILL HOLBROOK

creator of *Kevin & Kell* and
On the Fastrack

Richard Thompson reminds all of us that the perfect cartoon is a seamless blending of art and writing. When they are each done at the highest levels and joined into a single sensibility, the effect is magical. I am delighted and honored to be a part of this tribute to his immense talent.

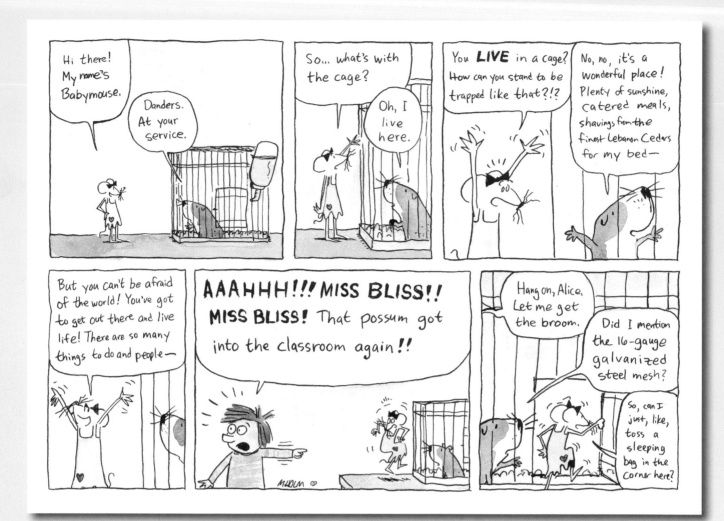

MATTHEW HOLM

graphic novelist, *Babymouse*

Finding a cure for Parkinson's disease is a cause that's very near to our hearts. Our father suffered from Parkinson's near the end of his life, as did his brother, nine years younger, who died before him. We always admired the way Dad faced his struggle with Parkinson's with stoicism and quiet good humor. And since Dad was a ravenous reader his entire life, as well as a fan of comic strips (his bound volumes of *Prince Valiant* were a prized possession), it's hard to think of a better way to both honor him and take a whack at this disease than with a book of comics-inspired art. Go, Team Cul de Sac!

—Matthew and Jennifer Holm

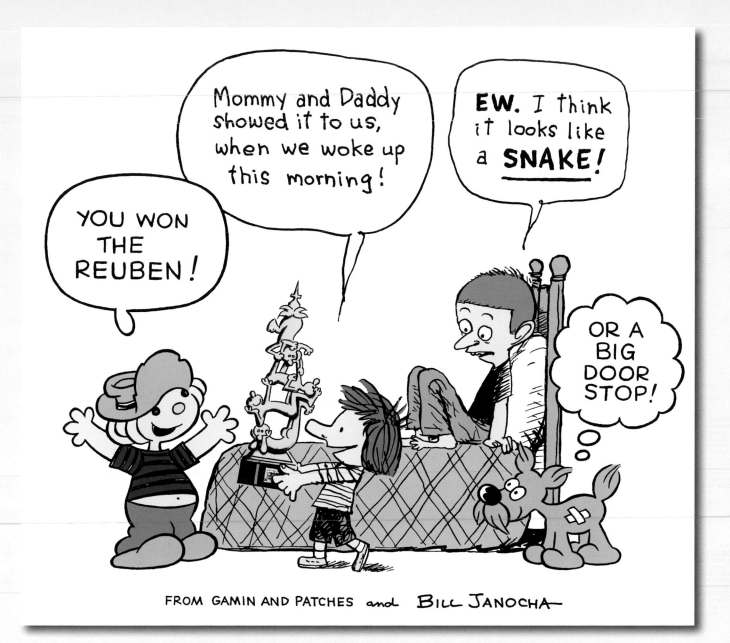

FROM GAMIN AND PATCHES and BILL JANOCHA

BILL JANOCHA

cartoonist, *Beetle Bailey*

As of this writing, only recently have I had the pleasure of enjoying *Cul de Sac* and marvel at both the unique art and characters Richard so masterfully transfers from his fertile mind to the blank page. Befriending Richard in person is an equally enriching experience, as his kindness and generosity mirror his aesthetic prowess.

I wish him many more years of health and vision, in order to happily continue his stellar efforts that truly emulate the qualities that define only the best and most inspirational of cartoonists.

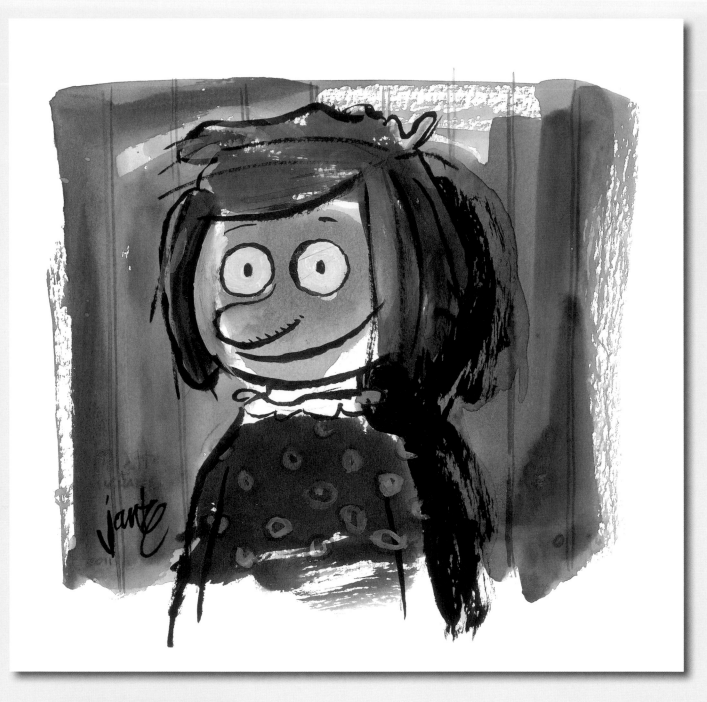

COLETTE AND MICHAEL JANTZE

creator of *The Norm*

Colette got the chance to audition for the voice of Alice in some *Cul de Sac* animation, and Richard immediately fell in love with her voice. Colette has played Alice in more than thirty new media shorts found on YouTube and other services. It was only appropriate that we paint a picture of Alice together . . . because tag-team portraiture is the wave of the future and has the same feeling of what this project and the umbrella MJF Foundation is about: working together and sharing talents. Colette did most of the inking; I selfishly got to do the shadow on the nose.

—Michael Jantze

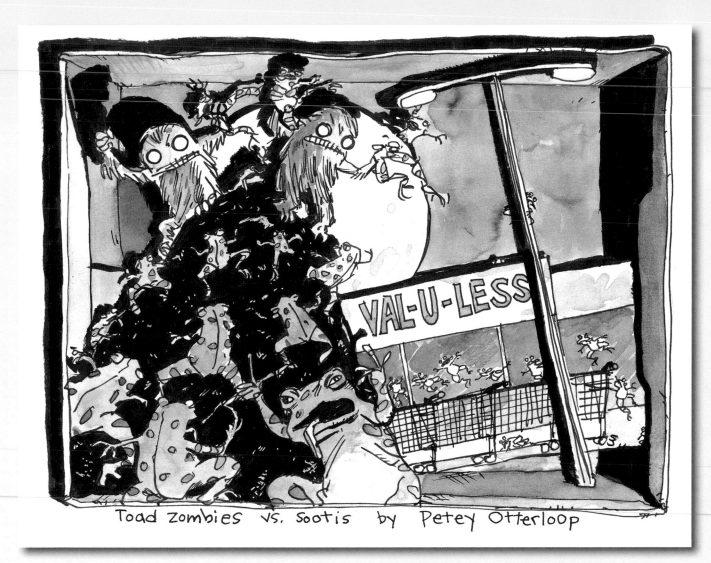

Toad zombies vs. sootis by Petey Otterloop

SANDY JARRELL

fan

I wanted to contribute because *Cul de Sac* is part of my day every day of the week, and I'm richer for it. I'm more than happy to give back any way I can.

RAYMOND JARRELL

age 8

AARON JOHNSON

creator of What the Duck

Richard is a rarity. With equal parts artistic genius and really nice guy, I've had the privilege of knowing Richard as a confidant, a colleague, and a mentor. His body of work is impressive. His comic strip is brilliant. His accessibility at two o'clock in morning has been invaluable! Thank you, Richard.

IAN JOHNSON
illustrator

Truth be told, among such cartoon greats as Jim Davis, Mort Walker, Bill Watterson, and Richard Thompson, I am the interloper. The only cartooning experience I've had is doing my own badly drawn comic strip for the community college newspaper I attended five years ago.

Team Cul de Sac is a wonderful project that I literally stumbled upon while searching for illustration competitions as a favor for a friend of mine who was gearing up to graduate college. What caught my attention was the artwork from Bill Watterson. I had to investigate further. From the Team Cul de Sac blog I started reading the comic. That's where I became a fan of Richard's loose inking style and the mini universe he created for Alice Otterloop and her friends.

I am deeply honored and humbled just to be a part of this worthwhile cause to fight Parkinson's alongside cartoonists I admire.

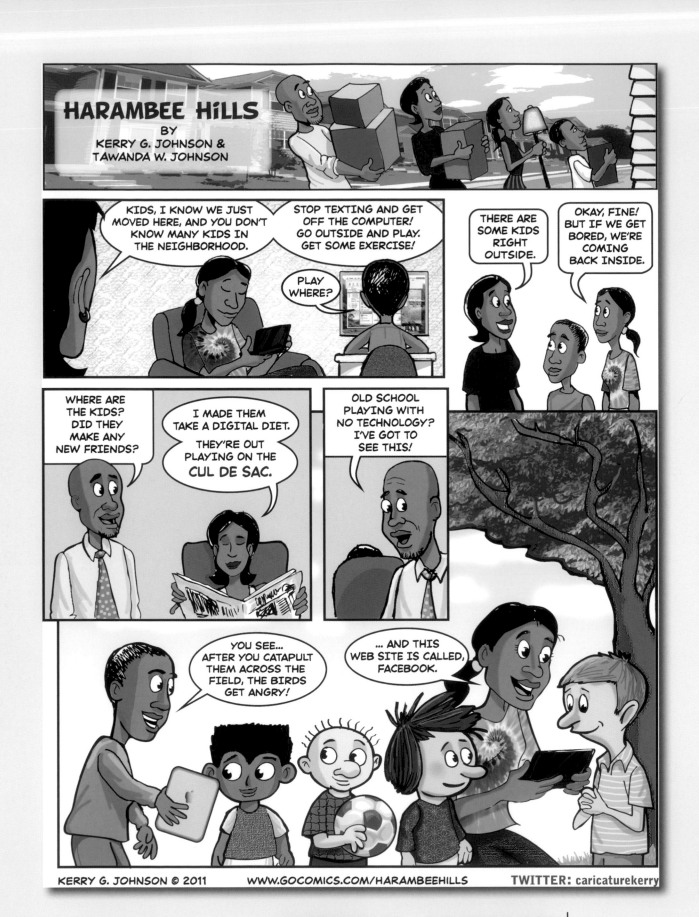

KERRY G. JOHNSON

illustrator

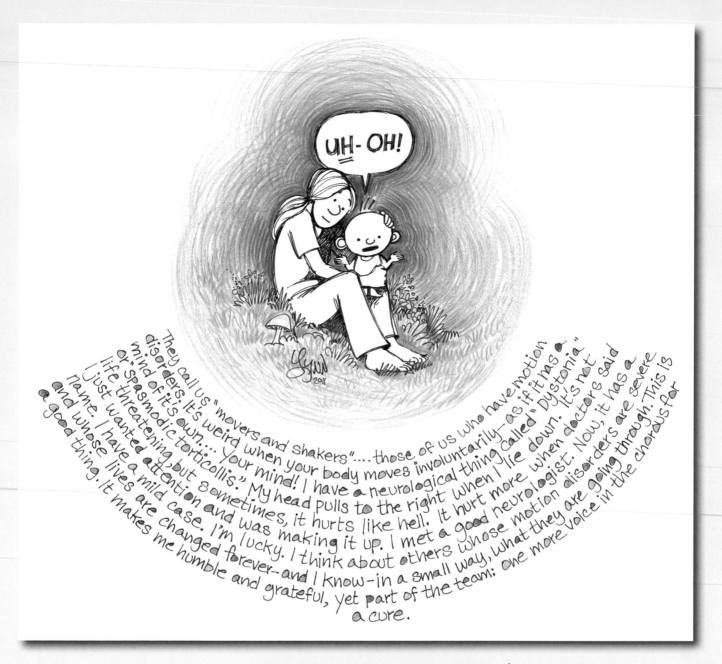

LYNN JOHNSTON

creator of *For Better or For Worse*

I couldn't think of anything funny. I thought about my own small concern, and all I could think about was movement (the lines of colour around the characters), affection— and a cure! What a crazy life this is!

DOUG JONES
illustrator

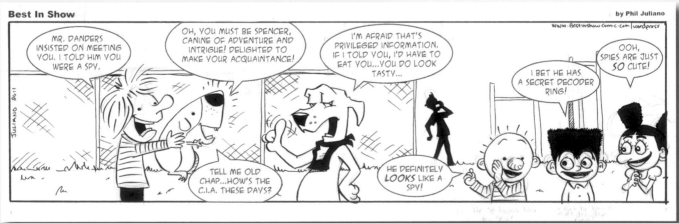

PHIL JULIANO
creator of *Best in Show*

It's amazing to see how this project developed from an offer of support for a friend into the huge production that it has become. It's even more amazing to see how so many talented and respected artists donated their work to such an honorable cause! Best of luck, Richard!

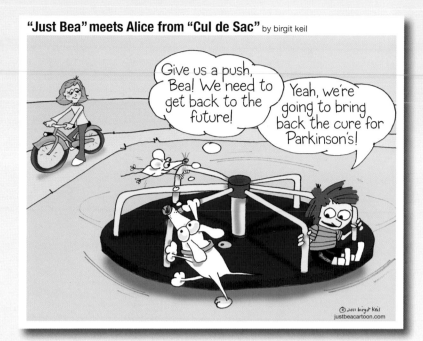

BIRGIT KEIL

creator of *Just Bea*

DAVE KELLETT

creator of *Sheldon*

Richard is one of those rare gems in cartooning: a kind heart, a brilliant line, a cutting wit, and a quiet sense of joy amid it all. It's as much a delight to meet and chat with him as it is to get to know him through his work. He's a once-in-a-generation cartoonist.

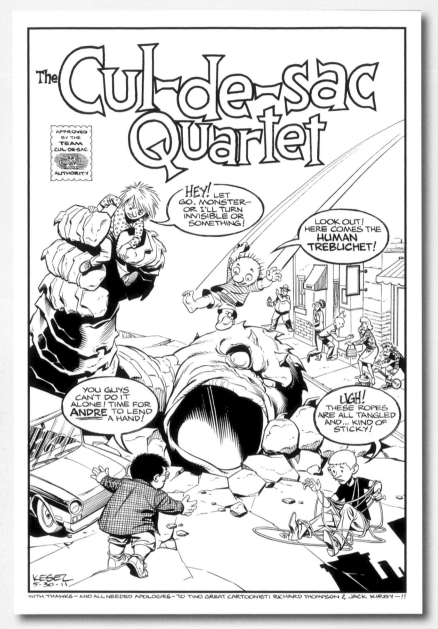

WITH THANKS — AND ALL NEEDED APOLOGIES — TO TWO GREAT CARTOONIST: RICHARD THOMPSON & JACK KIRBY —!!

KARL KESEL

comic-book cartoonist

I remember the first week *Cul de Sac* started running in our local newspaper. It was laugh-out-loud funny and beautifully drawn. It had a spark and life that has become, sadly, all too rare in newspaper comics.

The news that Richard has Parkinson's was a hard blow. Coming from a family with a history of Parkinson's, I know that nothing is more frightening to an artist than the thought he'll lose his ability to draw. It shouldn't happen to anyone. And so: this project. Cartoonists doing what they do, so researchers can do what they do, so cartoonists (and everyone else) can keep doing everything that they do.

JAMIE KING

artist and webmaster

I chose oil pastels for my piece since they tend to take on a childish quality. I depicted Alice at the height of frustration—something we artists often feel. Here's to Richard, whose brillance make it look all too easy.

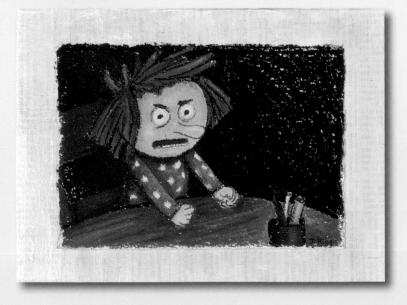

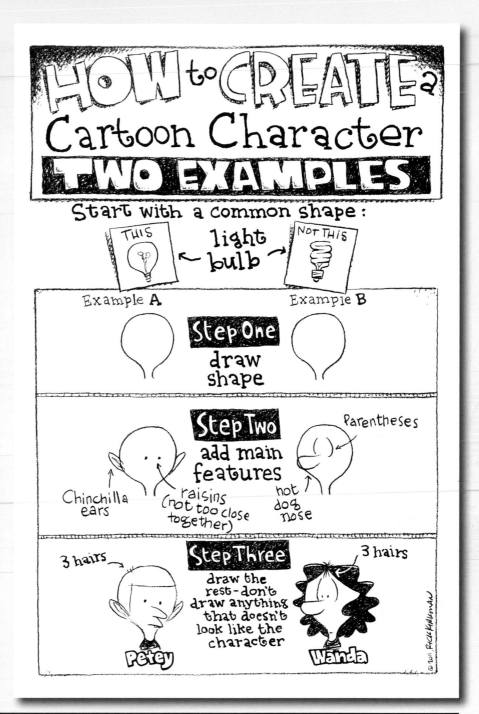

RICK KIRKMAN

cocreator of *Baby Blues*

One of the things that make a cartoonist's work great is that it speaks to us on different levels. That's what Richard Thompson's work does to me—but I don't mean in just words. Those scratchy, scribbly, messy drawings of his are also elegant, complex, and sophisticated. They're bent in a quirky perspective as if they filter through his own weird prism.

His view of the world is layered. You can literally see those layers in his drawings and paintings; sometimes his characters are transparent, with the backgrounds running through them. You don't learn how to do that. It takes an eye that's different from everyone else's. It takes a brain that's different, too: one that allows the hand the freedom to scratch its way into something beautifully odd with pen on paper.

It's the kind of art that inspires me. And thanks, Richard, for that.

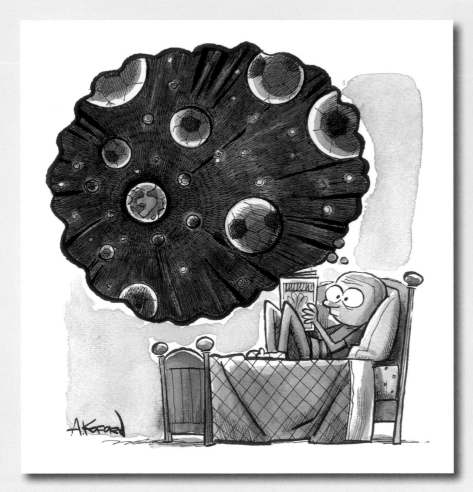

ADAM KOFORD
illustrator

I first became familiar with Thompson's illustration of Beethoven, frown perfectly arched across his stern face, twenty years ago. Fast-forward to the 2000s, and I started seeing Thompson's wonderful spot illustrations everywhere: *Time*, the *New Yorker*, the *Smithsonian*. Then came *Cul de Sac*, restoring my faith in newspaper comic strips as a forum where genius can flourish. I'm so glad Richard Thompson can thrive as a syndicate newspaper comic strip artist. He's perfect for it, and he's created the perfect comic strip. Long may it run.

SUSAN CAMILLERI KONAR
cartoonist and illustrator

I have only met Richard once. However, I can only say that his warm, generous personality made me feel like I was an old friend. When I found out about Team Cul de Sac, I couldn't wait to bring his cartoon world together with mine. It's a simple contribution to a great project. Richard, I wish you all the best, and can only say you are one class act.

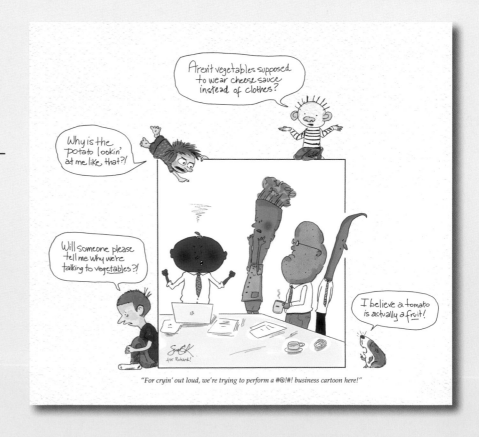

"For cryin' out loud, we're trying to perform a #@!#! business cartoon here!"

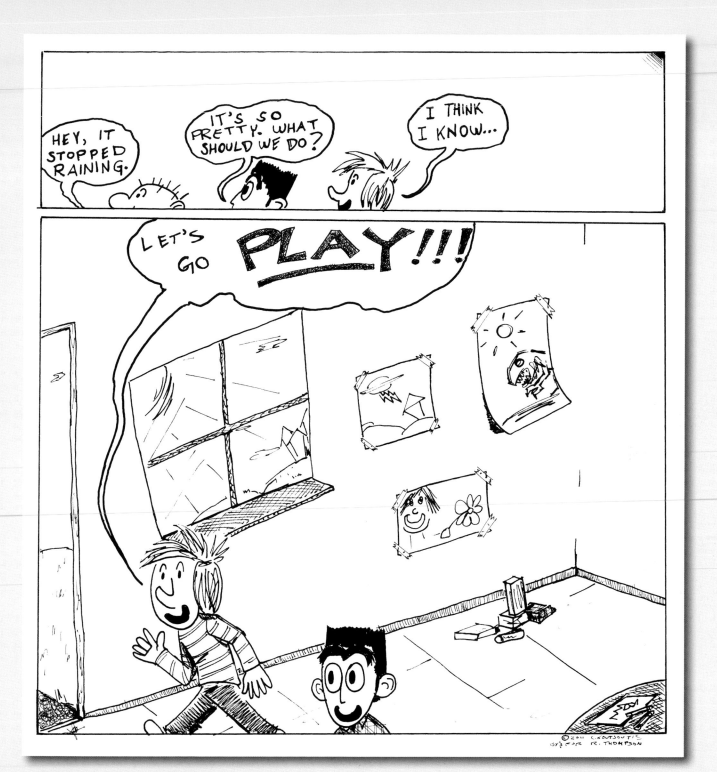

CONSTANTINE KOUTSOUTIS

cartoonist

It shouldn't work. It really shouldn't. Because the formula of adorable kids and the contrast between them and adults has been done to death. But, somehow, *Cul de Sac* has managed to not only stand out in the newspapers but elevate the newspaper comic strip and make it graphic storytelling art, all while still having pure heart. You can't explain why, but it's amazing, and you love it and want every newspaper in the world to carry it. Which they should.

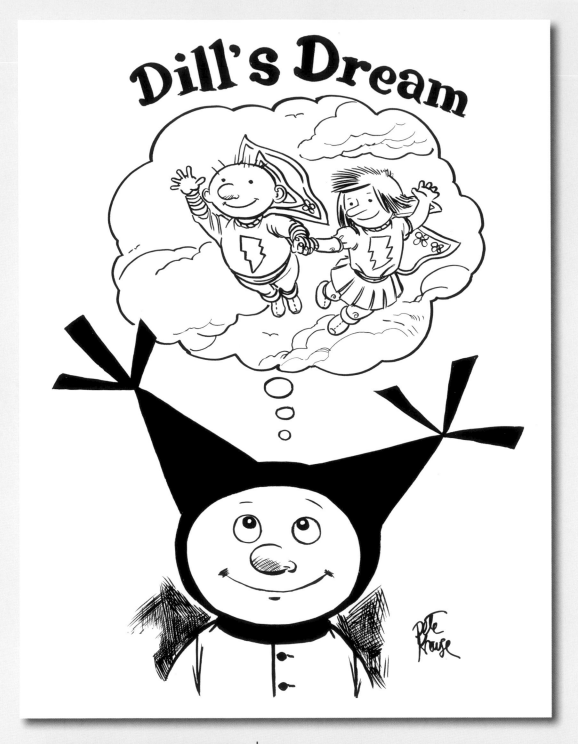

PETER KRAUSE

comic book artist

I read the comics section in our local paper because of *Cul de Sac*. And I love *Cul de Sac* for all the charming characters, but especially Dill. Socially inept, well intentioned, and in love with Alice—as much as a preschooler can be in love—Dill is close to my heart. And perhaps my personality. But there is no doubt that *Cul de Sac* and Richard Thompson belong in the pantheon of eminent cartoon strips and their creators.

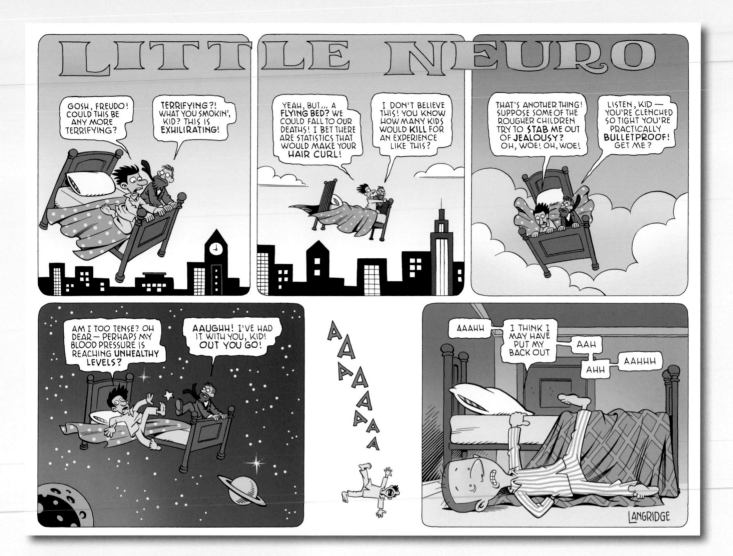

ROGER LANGRIDGE

comic book illustrator

I've been fortunate enough to meet Richard Thompson on a few occasions at comic conventions and to have a chance to talk to him over a drink or a meal. I love the way his wit works—he can be talking about something apparently seriously, then, with great comic understatement, he'll just slip in a zinger in the most casual way, to devastating effect, as if it were the most effortless thing. As if he himself didn't even notice it. His comics work the same way. He is also one of those great rarities, somebody who doesn't open his mouth unless he has something interesting to say. Fortunately, Richard Thompson has a lot of interesting things to say!

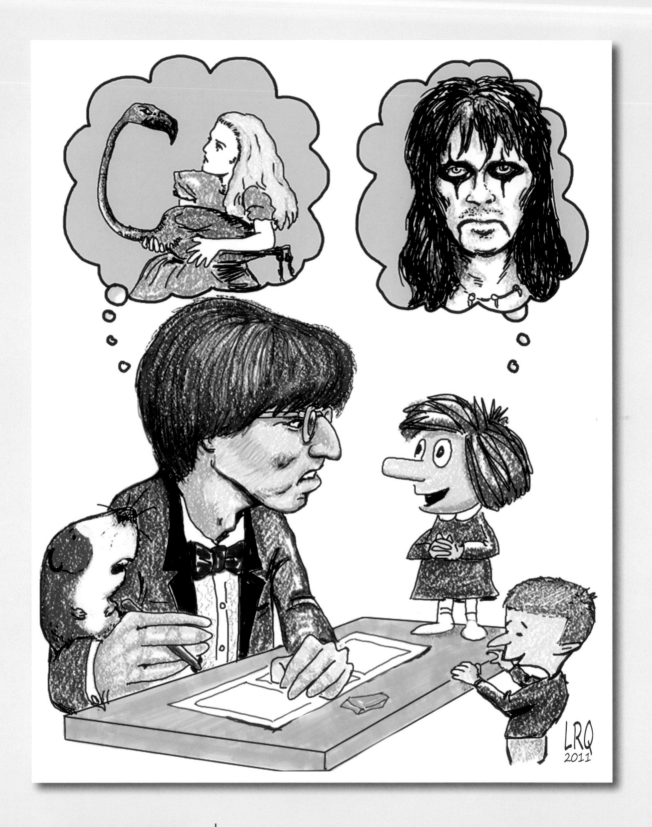

BILL LAROCQUE

caricature artist and cartoonist

I met Richard Thompson around 1994 at the Art Wood Collection of Caricature and Cartoon in Washington, DC. We were both drawing at a fund-raiser and sitting at opposite ends of a table. For fun, we did each other. His caricature of me is still hanging on my wall; mine (of him), I'm told, is lining Mr. Danders's cage.

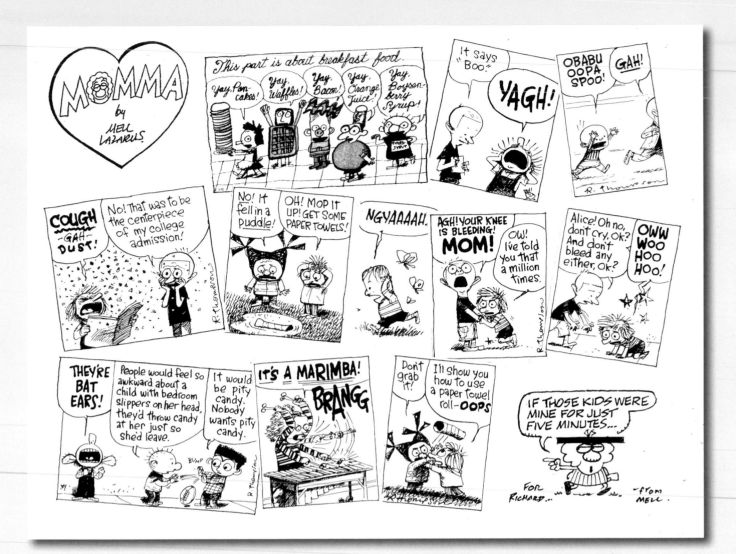

MELL LAZARUS
creator of *Momma*

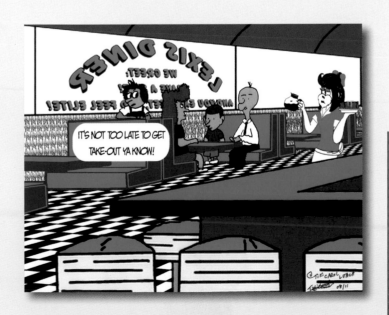

"TIKI" CAROL LEACH
creator of *Lexi's Diner*

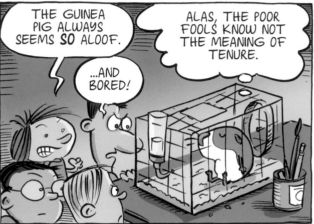

J. LEMON

creator of *Rabbits Against Magic*

It's the true sign of a great cartoonist that when you read his or her strip for any length of time you get an urge to throw away your inks, snap your crow quills in half, and go back to serving mochas and decaf cappuccinos. Richard Thompson should be up there on the Mount Rushmore of comic strip cartoonists alongside Schulz, Herriman, and Watterson.

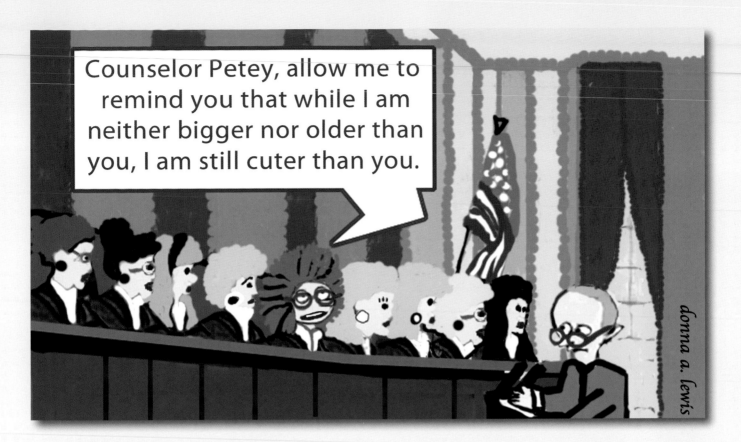

DONNA A. LEWIS

creator of *Reply All*

Thank you to Team Cul de Sac, the Michael J. Fox Foundation and Andrews McMeel Publishing for allowing me to contribute. And thank you to everyone who is contributing so that we can raise awareness about Parkinson's. Thank you to the delightful Chris Sparks for leading the Team. I am honored and grateful for the opportunity to support such a good cause.

Richard is living proof that while the biggest challenges may nourish and enlighten our journey, there is much, much more to our journey than our challenges.

Richard is my hero. And, it just so happens that Richard is also one of my favorite cartoonists.

And yes, I absolutely believe that our spunky and colorful Alice will go into law when she grows up. Even if I have to paint the vision in oils to pass muster with the Richard Thompson fan club.

TERRI LIBENSON

creator of the *Pajama Diaries*

My grandmother Mollie, whom my older daughter is named after, had Parkinson's. She had it throughout my lifetime, so I never knew her without tremors, speech difficulty, or the ability to walk on her own. Needless to say, it was severe and debilitating.

It was also debilitating for our relationship because I never got to know her well enough due to the nature of her disease. She died when I was 13. All I knew from personal interactions was that she was gentle, exceedingly sweet, and she never complained. It took my glancing up at her walls from my usual perch on her living room floor to discover that she had been a gifted painter in her earlier years. The few gorgeous oil paintings that graced her small apartment were a testimony to the creative spirit inside.

I value this opportunity to be part of Team Cul de Sac . . . not only because I'm a big fan of Richard's work (and because I love drawing cartoons) but because it gives me a chance to do something for my Grandma Mollie, whom I'm sure was blessed with a wicked sense of humor on top of all her other amazing traits. God bless, Richard!

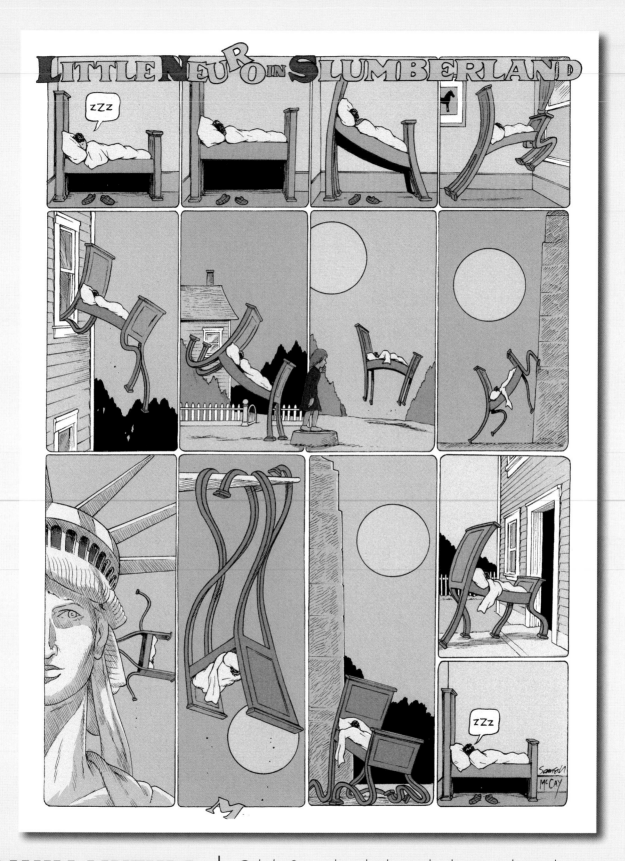

SAMULI LINTULA

creator of *Dark Side of the Horse*

Cul de Sac is hands down the best syndicated comic strip currently out there, and Richard is a huge inspiration for us all. I'm deeply honored to be a little part of this great project.

RENE LOPEZ

creator of *Glenview Revue*

JOHN LOTSHAW

creator of *Accidental Centaurs*

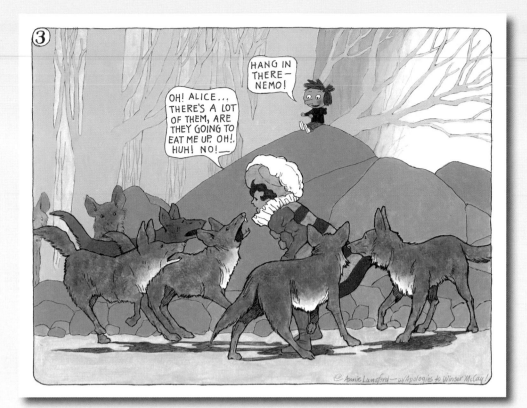

ANNIE LUNSFORD

illustrator

I met Richard years ago, before he was world famous; just amazing and brilliant! He's got the winning combination—wit, and he can draw! Richard's the best, and I hope all the money raised can really help.

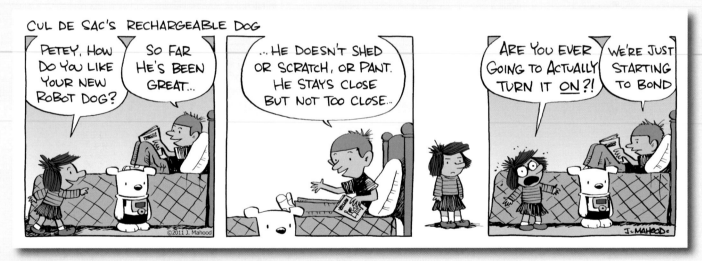

JONATHAN MAHOOD

creator of *Bleeker the Rechargeable Dog*

Having suffered some permanent nerve damage that left my drawing hand partially paralyzed, I have some limited insight into what it's like when your wiring doesn't quite function properly. Drawing a simple circle can suddenly become extremely frustrating. I also know that, while I was working through therapy and coping with this new reality, comics were a powerful source for that healing, both physically and mentally. For that reason, I think comics provide an excellent and unique way to promote awareness and raise funds for Parkinson's research. I am very pleased to play a role and support Richard's Team Cul de Sac. Dip those nibs, people!

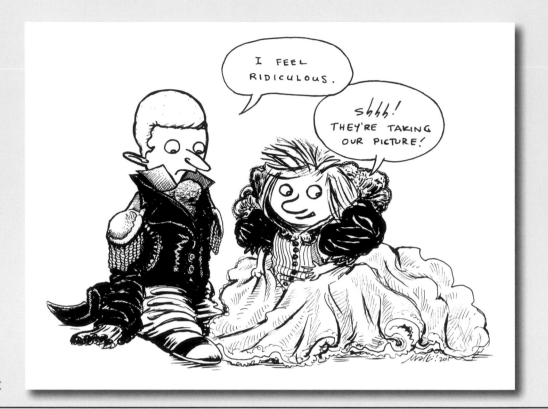

DAVID MALKI

creator of *Wondermark*

I'm so grateful for *Cul de Sac*—it reminds me of how smart, how fun, how beautiful, and how weird comic strips can be. And Richard makes it look so incredibly easy, for which I'll always bitterly hate him.

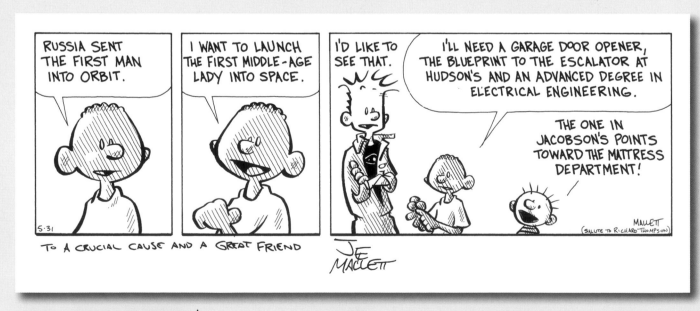

JEF MALLETT

creator of *Frazz*

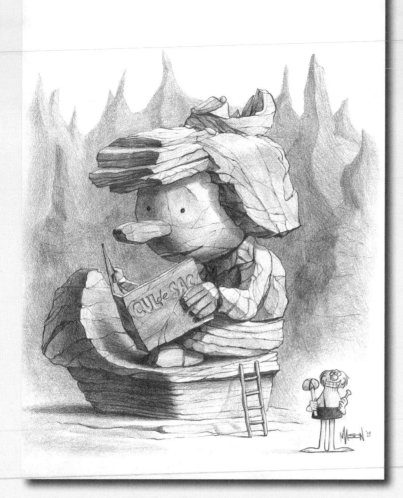

MASON MASTROIANNI

artist, *B.C.*

I'm humbled and privileged to be part of this project, which simultaneously honors a wonderful cartoonist while shedding light on this dreadful disease. Your strength inspires me.

DON MATHIAS

Web cartoonist

Cul de Sac is up there with the best of the best of all comics. The most important thing for a fellow cartoonist is how well the characters play with others.

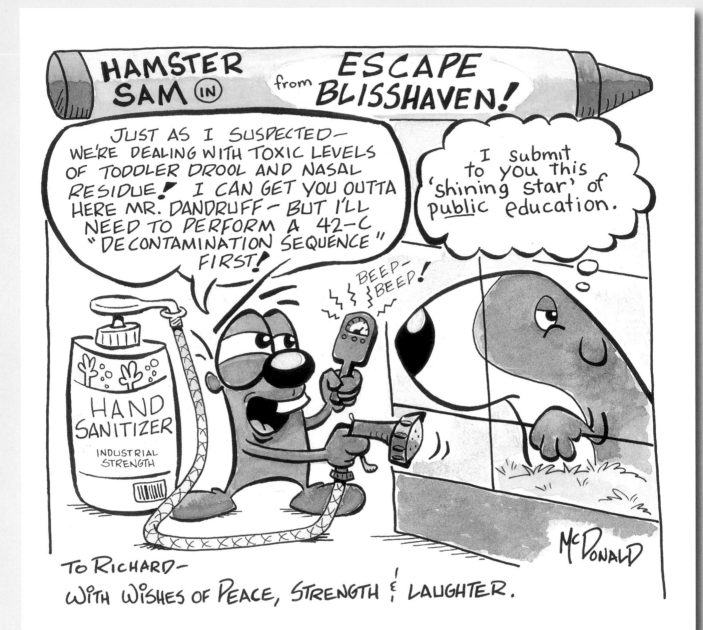

DAVE MCDONALD

creator of *Hamster Sam*

When I first met Richard, I knew it instantly: He's that kid in the neighborhood that everyone wants to be friends with; funny, clever, kind. He's the kid who has the best toys but shares them with everyone. He's the kid whose team I want to be on.

Thank you, Richard, for inviting me over to play.

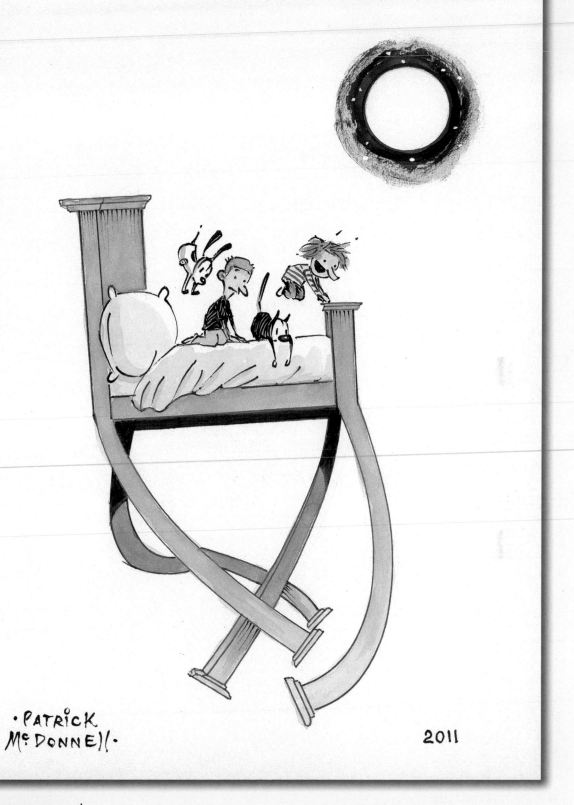

PATRICK McDONNELL

creator of *Mutts*

Richard Thompson's *Cul de Sac* is a classic. With its wonderful writing, masterful drawing, and expressive characters, it has the magical quality of joy and intimacy that is found in all the truly great comic strips. It's one of the best.

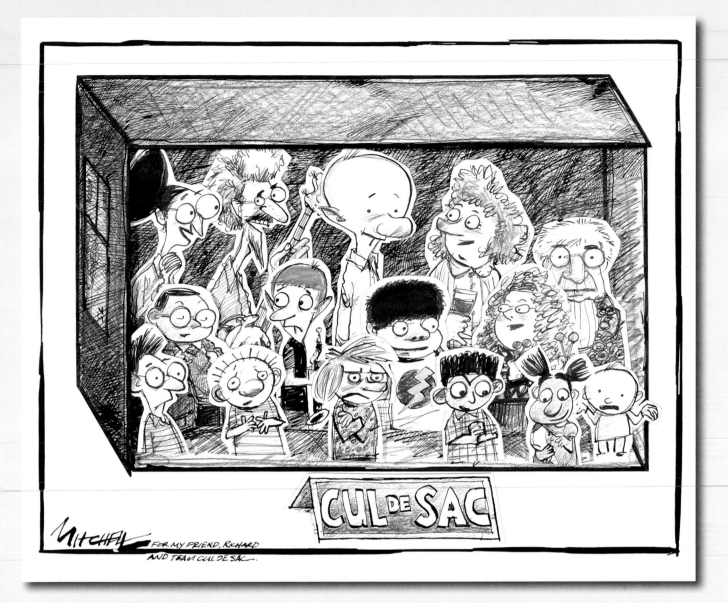

BILL MITCHELL

political cartoonist

Over the years, Richard's work, his line and wit and originality have been a constant inspiration for me to improve my own work. But it's Richard's grace and humor and intelligence that has challenged me to be a better person, and I am honored to this day to call him my friend.

BONO MITCHELL

graphic designer, art director, and artist

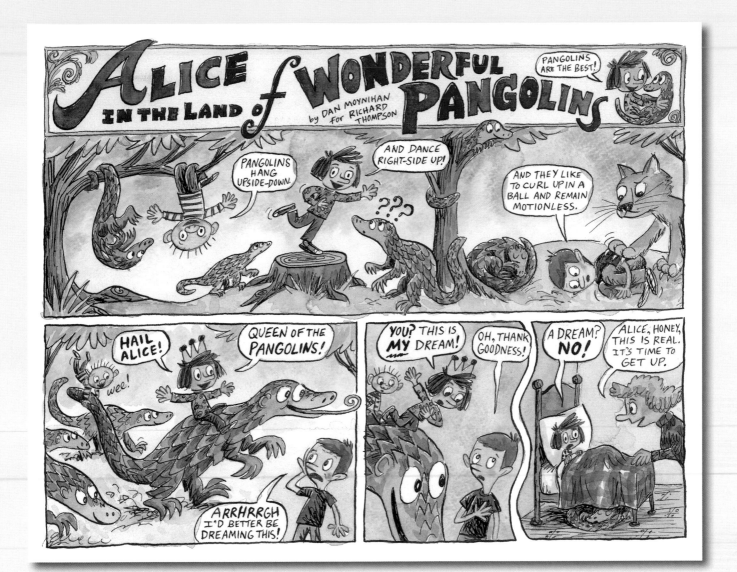

DAN MOYNIHAN

illustrator and cartoonist

I don't know Richard Thompson personally, but his comics have so much life, humor, and warmth in them that I think he must be a great guy—he's a great cartoonist, anyway! I am amazed by his energetic drawings and whimsical imagination. You can see his unique vision and verve even in the way he draws an electrical outlet or a soap dispenser, but even more so in the wonderful characters he has created.

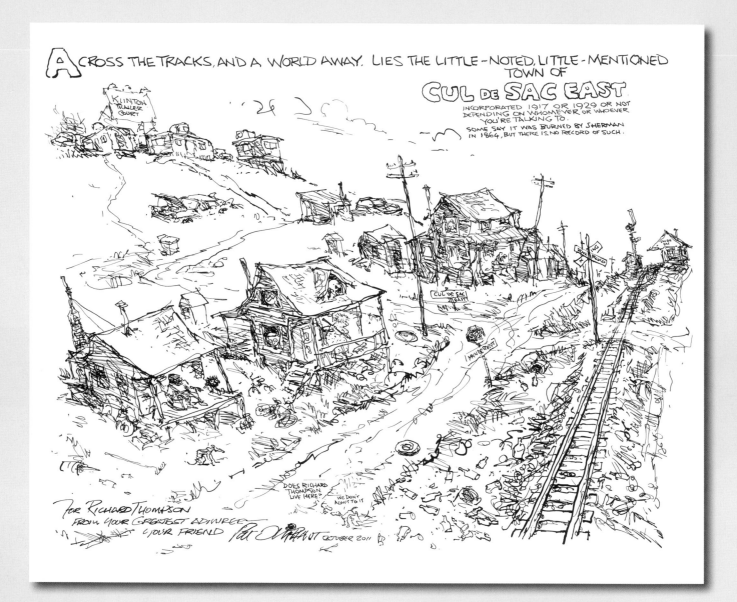

PAT OLIPHANT

editorial cartoonist

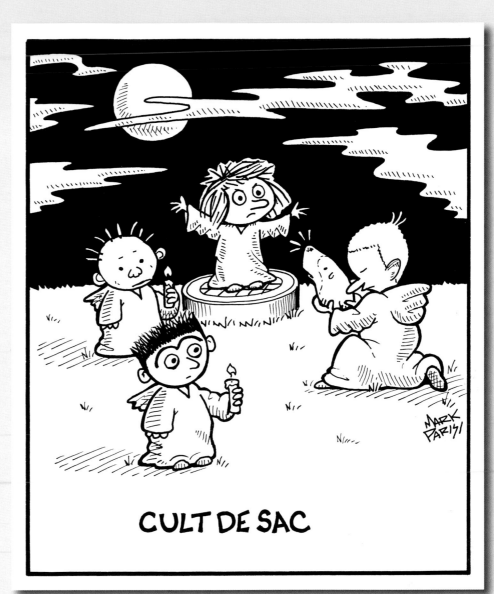

CULT DE SAC

MARK PARISI
creator of *Off the Mark*

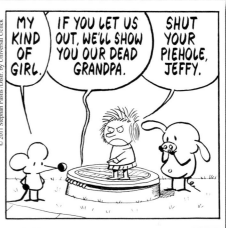

Panel 1: LOOK, RAT! IT'S ALICE FROM THE COMIC STRIP 'CUL DE SAC,' AND SHE'S STANDING ON THAT MANHOLE COVER LIKE SHE ALWAYS DOES! HOW COME YOU ALWAYS DO THAT, SWEET L'IL ALICE?

Panel 2: I'VE TRAPPED THE @☆#@☆#@ 'FAMILY CIRCUS' KIDS IN HERE.

Panel 3: MY KIND OF GIRL. — IF YOU LET US OUT, WE'LL SHOW YOU OUR DEAD GRANDPA. — SHUT YOUR PIEHOLE, JEFFY.

STEPHAN PASTIS
creator of *Pearls Before Swine*

LINCOLN PEIRCE

creator of *Big Nate*

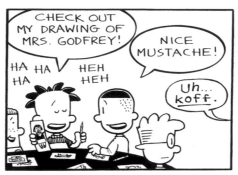

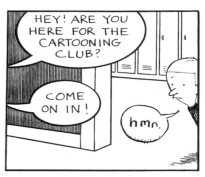

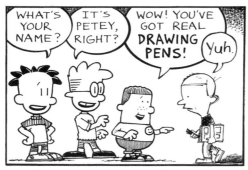

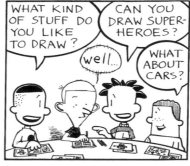

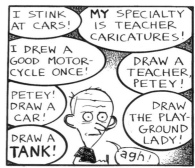

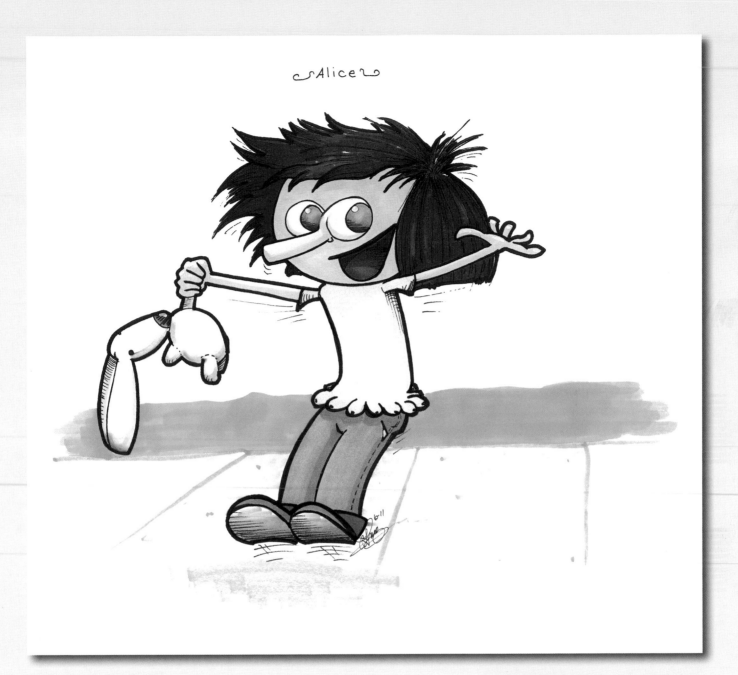

CHARLES PERRY

cartoonist

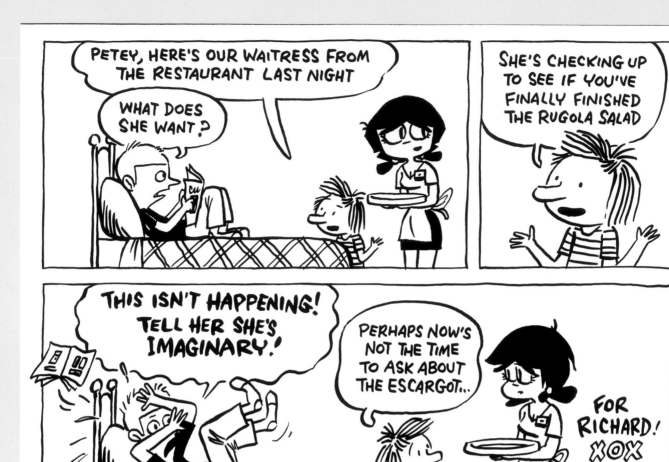

RINA PICCOLO

creator of *Tina's Groove*

If I didn't know Richard, I would read *Cul de Sac* and wonder about the man behind the characters. Is he sensitive, intuitive, distinctively brainy? Or is he just awesomely neurotic?

All of these things are true about Richard. He's the spark that gives *Cul de Sac* its charm. I'm so glad to know him. Oh, and did I mention he's an alchemist at the drawing board? Turns ink and paper into pure gold!

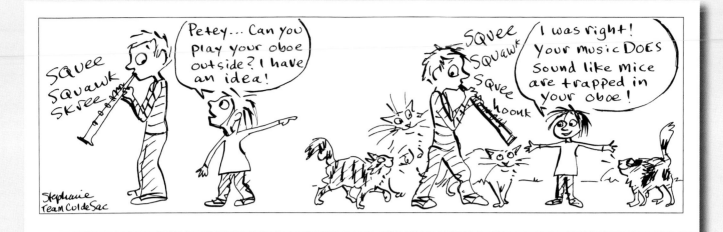

STEPHANIE PIRO

creator of *Six Chix* and *Fair Game*

Cul de Sac is the only cartoon I read on a daily basis. Alice and Petey are two of the most memorable characters to appear in comics in a long time, beautifully drawn and intelligently written. And funny! I love it!

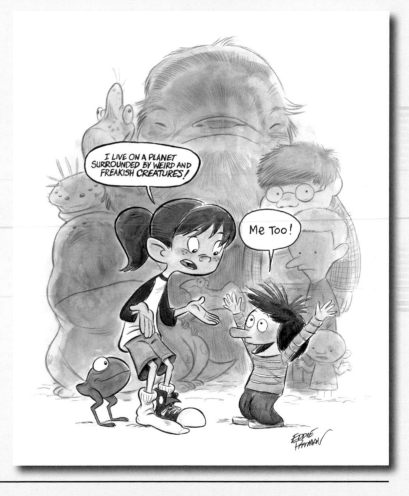

EDDIE PITTMAN

creator of *Red's Planet*

Cul de Sac is a member of our family. Our lives are peppered with inside jokes inspired by the comic; it's crept its way into our family lexicon with phrases like "bread pincher thingies" and "portent of doom." My oldest daughter even gnaws her arm when we've piqued her frustration.

As a cartoonist, I have to admit that Richard Thompson has become somewhat of a hero of mine. *Cul de Sac* inspires me, like *Calvin and Hobbes* before it, and *Pogo* before that. He challenges the fallacy that comic strip writing is more important than art as he wields both with the skill of some kind of comic strip ninja. Or, even better, Zorro.

Richard Thompson is my Zorro!

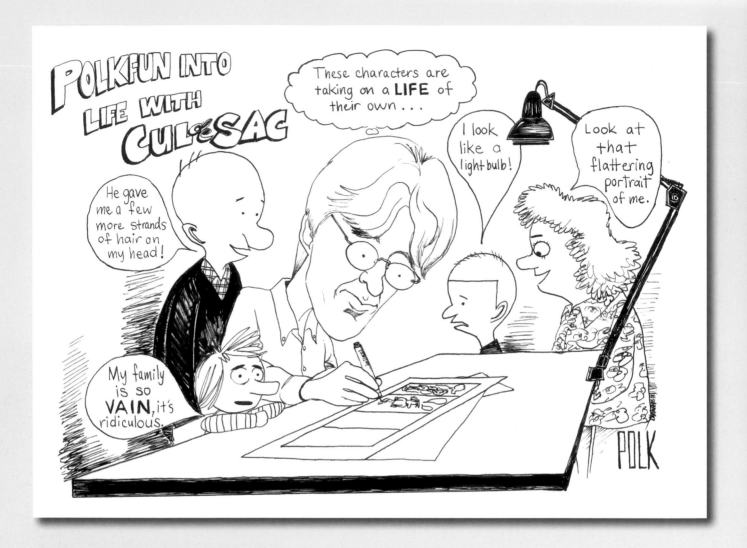

JERRARD K. POLK

caricature artist and illustrator

I had the pleasure of meeting Richard Thompson at the Heroes Convention. Once I shared my vision, he saw it, and complimented me on the caricatures I was sketching on the spot of friends and passersby. A vote of confidence from the cartoonist of the year does much to build up and encourage the recipient. I also am thoroughly encouraged by the effort that Richard puts forth to produce such an excellent strip. I had no idea that he had Parkinson's until some time after I met him, but you can't help but possess an even greater appreciation for him after the fact. Hurray for Richard Thompson and Team Cul de Sac!

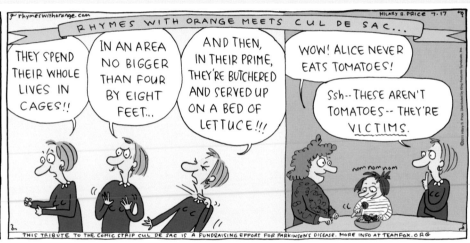

HILARY PRICE

creator of *Rhymes with Orange*

I knew I wanted to feature Alice because I've been waiting for her on the comics page my whole life. I feel like my personality is bookended on the one side by Peppermint Patty and on the other by Alice Otterloop. I am the youngest of three, and when I got around to asking my mom what I was like as a kid, she just said, "sticky." Both Alice and Peppermint Patty remind me of what it was like to be sort of weird, and at the same time perfectly fine with that.

ERIC REAVES

cartoonist, *Garfield*

It was with great joy that I completed this art. While it is only a small gesture, I hope it helps the cause of Team Cul de Sac in some way. The copy on the art is so true. You are a comic genius, and most definitely a cartoonist! I forgot to add, "and an inspiration to everyone in the comic pages!"

I personally love your strip! I am one of millions who eagerly wait each day to see what fun drawings you have created and what wit and wisdom you will bestow upon us. I was truly saddened to hear of your diagnosis. If there is ever anything else I can do to help in your battle, please do not hesitate to ask.

SCOTT REMPE

illustrator

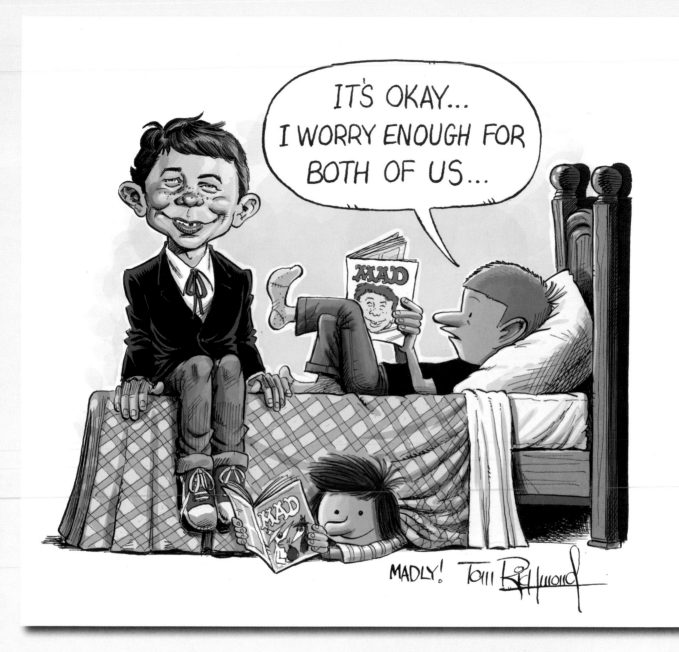

TOM RICHMOND

cartoonist for *MAD* magazine, and
president of the National Cartoonists Society

Few comic strips come along that instantly
jump into the realm of "classics," and *Cul de
Sac* is one of those rare breeds. Richard's art
and writing are a combination of charm and
brilliance that had me hooked from the first
panel. What a treat it is to get to enjoy his
humor and talents every day.

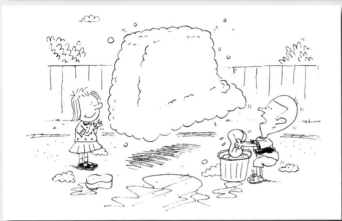

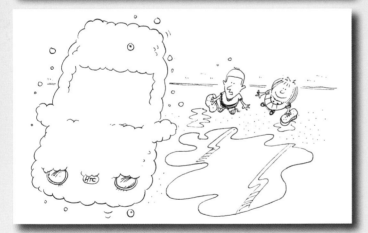

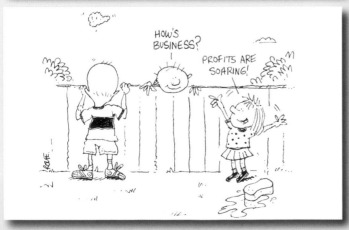

D. M. ROLFE

creator of *Mighty Monocle*

I'm a Brit, so I grew up with the work of Quentin Blake and Ronald Searle. I remember fondly, in my younger years quite literally, drooling over their beautiful, scratchy, inky artwork. I can categorically blame them both wholeheartedly for my early fascination with this art form.

However, I wouldn't class Richard Thompson in their league. No, Mr. Thompson is in a league all his own. Richard has a razor-sharp wit, impeccable comic timing, and a magic window into the inner workings of the childhood mind.

Thank you, Richard. It was a pleasure to be a small part of this very worthy cause.

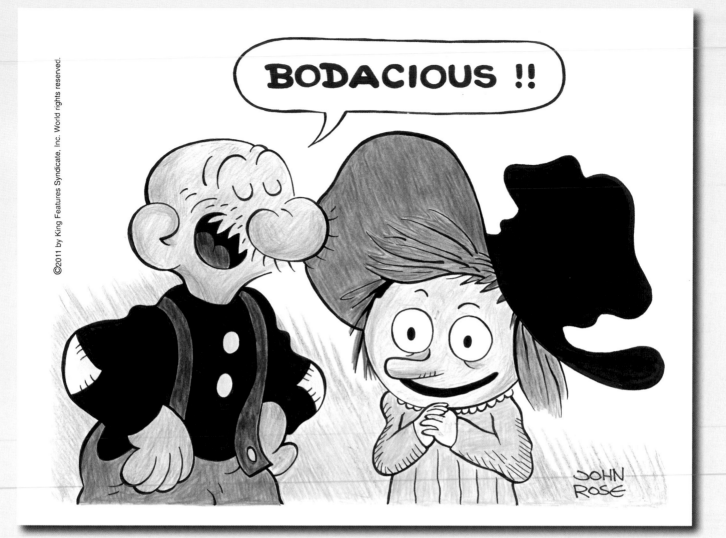

JOHN ROSE

cartoonist, *Barney Google and Snuffy Smith*

Although I've not yet had the privilege to meet Richard, I've enjoyed *Cul de Sac* for many years. His drawings are simply wonderful, and his strip makes me smile every day. Alice is my favorite character. She is one of the most fun little girls on the comic pages today. It's an honor to get to draw her alongside Snuffy and an even greater honor to participate in this Team Cul de Sac project.

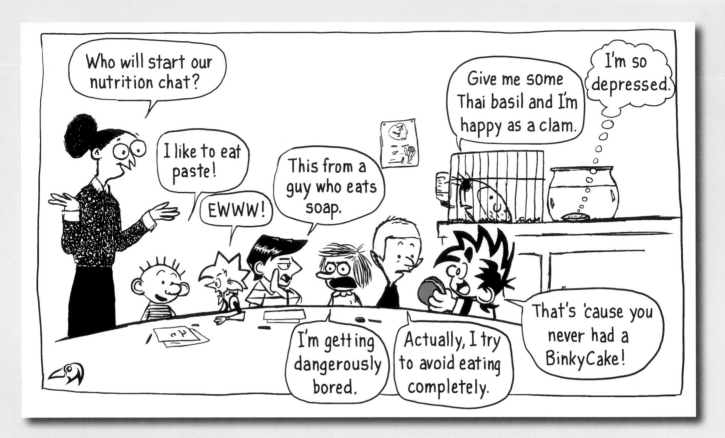

CROWDEN SATZ

cartoonist

Cartooning. Such a wondrous activity. First practiced by our great, great . . . (repeat a LOT of times) grandfathers in their caves as they memorialized their encounters with mammoths, bears, and all other sorts of other comical characters. If only they'd had written language, what gags they would have put down to go along with the pictures.

Cartooning is so easy that anyone who can hold a pencil can do it. But, like most things, only a very few can do it well. What I so admire about Richard's work is that, at first glance, it looks like anyone *did* do it. The best descriptor is "scribbled." Thin, spidery lines of ink that wiggle and dance. Like a child might do.

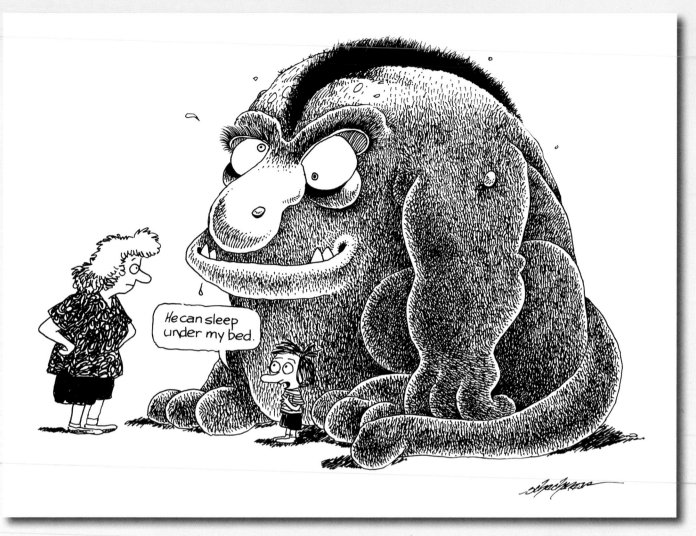

CHRIS SCHECHNER

cartoonist, illustrator, and art director

When I found out about Team Cul De Sac, I was excited to participate because, first of all, I love Richard's creation. It would be a great chance to honor this wonderful strip. Secondly, I want to encourage everyone with disabilities to achieve all they can. As the result of a diving accident nearly forty years ago, I have been quadriplegic, and I have continued drawing and creating art since then despite having my fingers paralyzed and having limited use of my arms. We all struggle with some form of obstacle, and it is important to push ourselves to reach beyond expectations. Thanks, Richard, for providing this platform.

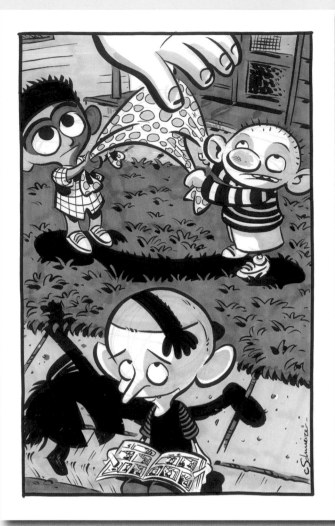

CHRIS SCHWEIZER

graphic novelist, *The Crogan Adventures*

I genuinely believe that Richard understands children better than any writer—and not just of comics—that has come before him. Most of us cartoonists are kids at heart, and hopefully have a little insight, but Richard so deftly presents the logic of the little that it makes the rest of us look like gripey old curmudgeons. For that, and for the hours of joy that come from reading his strip and sharing it with my family and friends, I offer him my sincerest thanks.

R. SIKORYAK

comic artist

Richard's strips bring so much humor and warmth to the comics page, he's helped revitalize the form. Although he doesn't paint on canvas, he is a true modern artist!

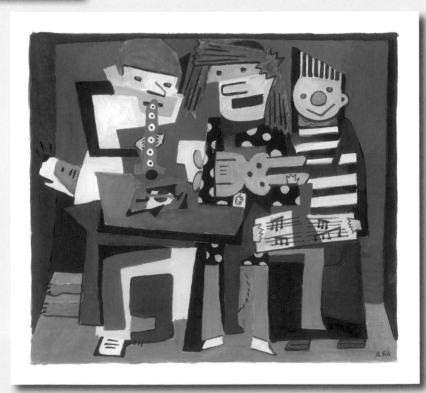

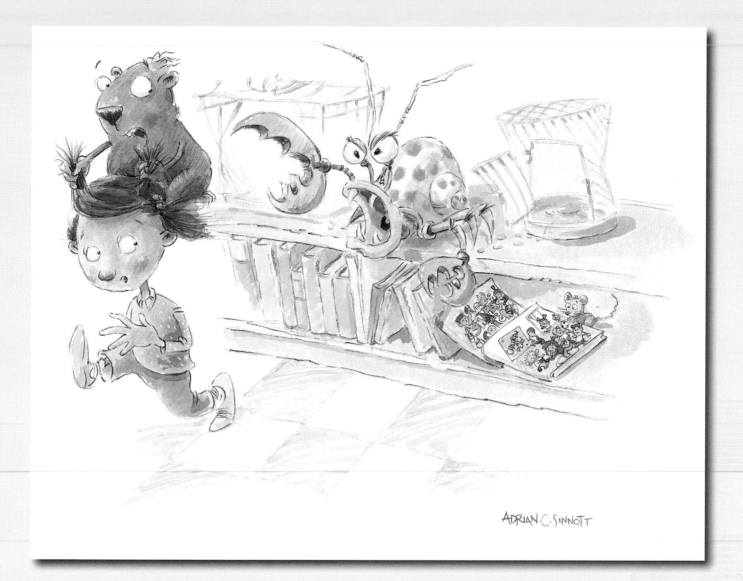

ADRIAN C. SINNOTT

illustrator

To paraphrase Gulley Jimson (Alec Guinness's character in *The Horse's Mouth*), "Of course you want to be a cartoonist. Everybody does, once. But they get over it. . . ."

Everybody, that is, except for the true cartoonist. For us, this isn't a job, it isn't a career—it's a calling. We cannot quench the desire to create anymore than we can stop ink from drying on paper. Take away our pencils and computers and we'll scratch it out in the very ground on which we stand. Threaten us with poverty, jail, or physical harm, and the true cartoonist will persevere in the desire to draw that one great, life-changing image. Whatever obstacles lie in our path, we'll sketch a way past. In this vein, Richard is a true cartoonist, and *Cul de Sac* the place that makes our lives better. It's all about making life bearable for others—one panel at a time. Thank you, Richard (and Alice!).

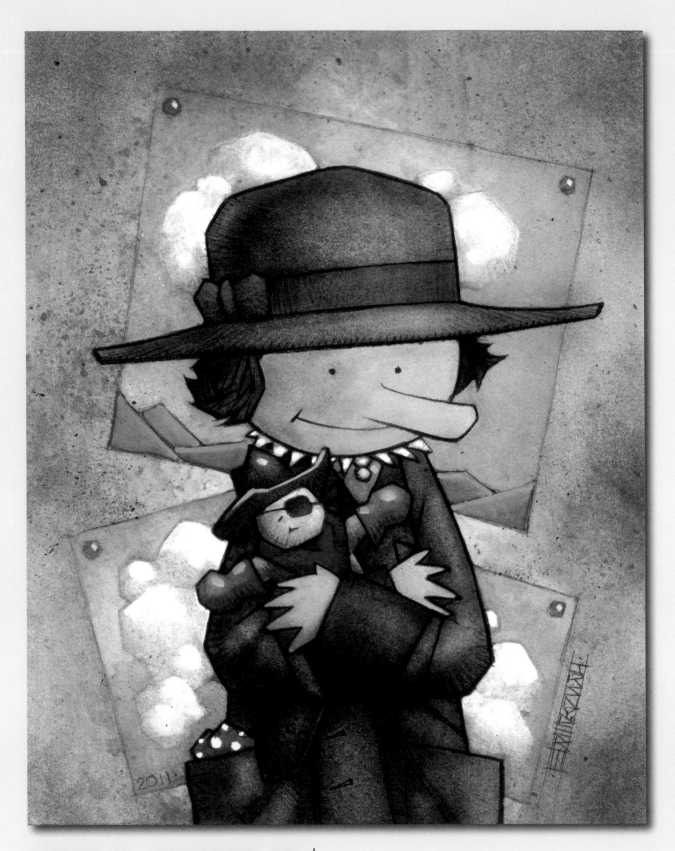

JOHN K. SNYDER III

comic book cover artist

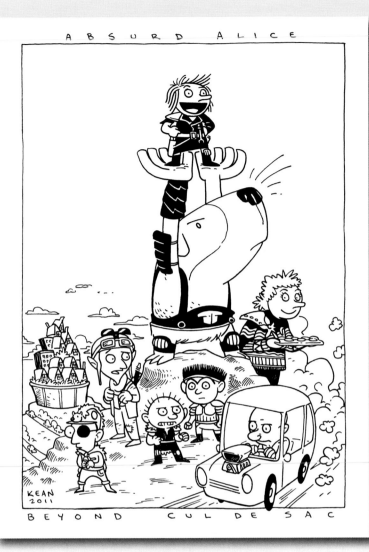

KEAN SOO

graphic novelist, *Jellaby*

Cul de Sac is very much its own world, where things like talking guinea pigs and Honda–Tonka Cuisinarts exist side by side with the daily things we all worry about, even when we were kids. Like clowns hiding in ceilings.

It's a world that I love and wish I was a part of; and in some ways, it's a place that I already live and play in. That's what makes *Cul de Sac* great, and why we love it so.

JEN SORENSEN

creator of *Slowpoke*

Unlike many daily strips, *Cul de Sac* doesn't pander to the lowest common denominator—it's intelligent, and it's not afraid to be a little weird (how many cartoon families are named Otterloop?). The artwork is lovely to look at. Would that I could draw so loosely and have everything come together so well! Also, it's refreshing to have a female kid character who isn't just a "straight man" (straight tyke?) for a boy character's antics. Alice gets to be funny!

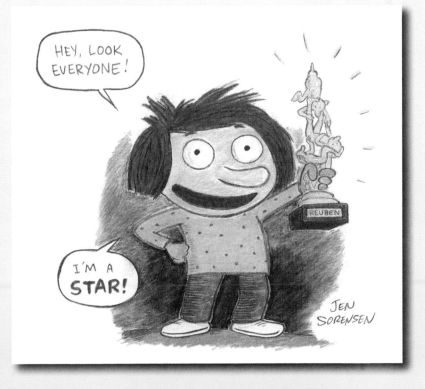

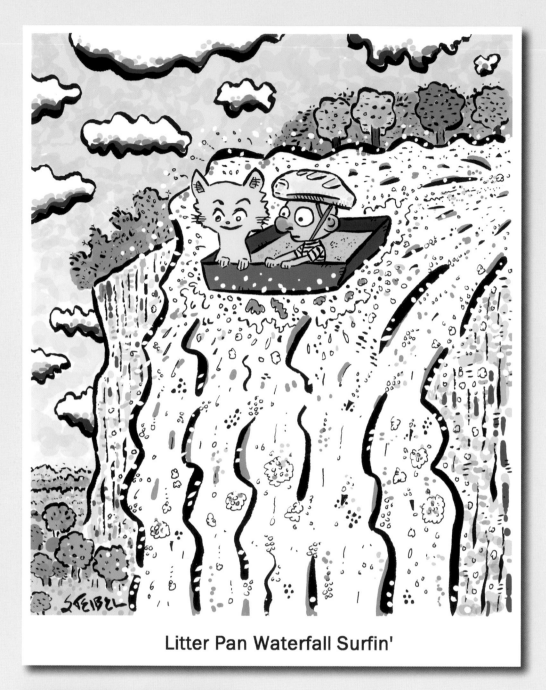

Litter Pan Waterfall Surfin'

ROBERT STEIBEL

cartoonist

Growing up in the DC area, there were always copies of the *Washington Post* piled around the house, so I've been a big fan of Richard Thompson's brilliant illustrations for many years. I recently heard Richard and some of his friends are starting a project called Team Cul de Sac where they're collecting original comics art to be auctioned off for the benefit of Parkinson's disease research. I just started doing my first official comic strip last week, so I feel pretty silly submitting a piece of my own work, but at least I have an excuse to send Richard this cartoon as a simple way of saying thanks for all of his great work over the years. Best wishes to Richard, his family, and everyone involved with Team Cul de Sac.

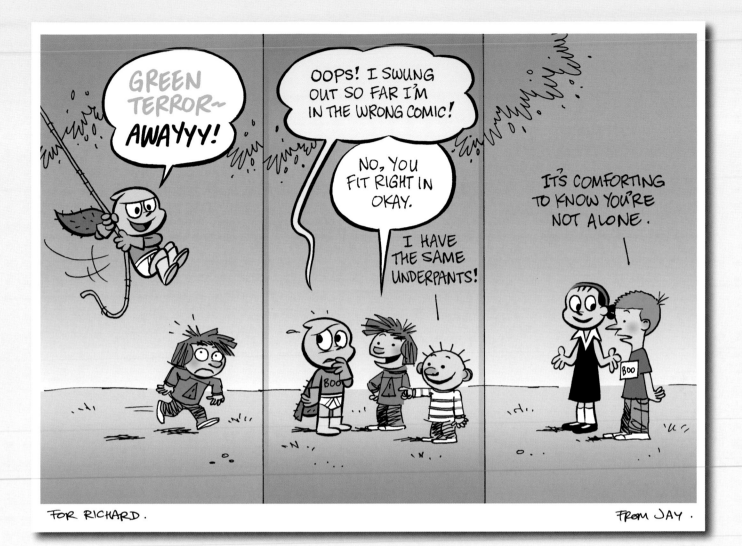

FOR RICHARD.

FROM JAY.

JAY STEPHENS

cartoonist and animator

Cartoonists are a tight-knit bunch.

A couple of years ago, I spent eight weeks in hospital recuperating from the rather nasty side effects of debilitating mental illness. As part of the ongoing treatment, my doctor recommended openly discussing my clinical depression with others, which I did, and continue to do. As expected, the diagnosis scared off many friends and family, some of whom abandoned me to my fate.

But not the cartoonists.

By a wide margin, those in the cartooning profession extended the most heartfelt sympathies, the kindest words of support, and extended the warmest hands of friendship. I felt so encouraged by that unconditional support, and will never forget it.

Cartoonists let me know in no uncertain terms that they are Family. Richard Thompson is my Brother. This is for him.

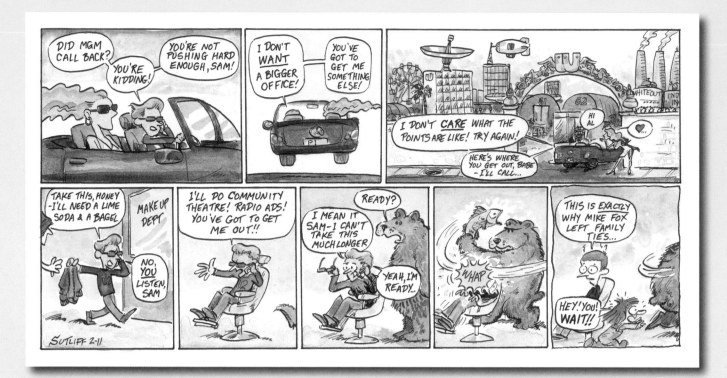

JOE SUTLIFF

cartoonist

"Richard is a cartoonist's cartoonist." I hear this time and again. His work is so finely crafted that sometimes it takes the experience of working in the medium to appreciate the complexity of his composition and writing, which appears so flowing and effortless. If I have one complaint at all about him, it is that Richard is too skinny. Whenever he travels to shows, he is forced to carry five pounds of pea gravel in his pockets to counteract sudden wind gusts. Next time you see him, ask to feel around in his pockets—you'll see."

SARAH TALLON

illustration student

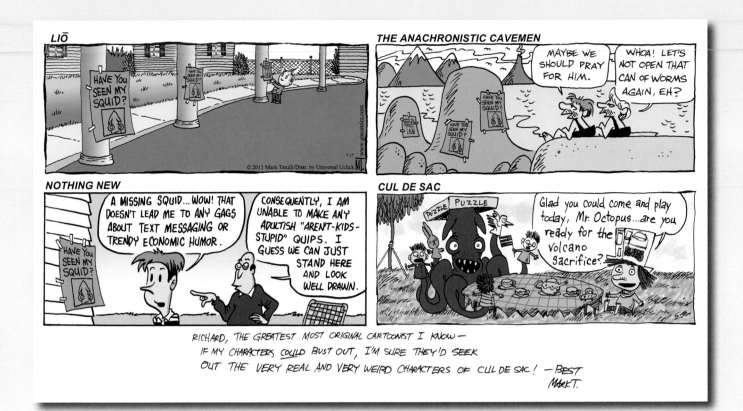

MARK TATULLI

creator of *Liō* and *Heart of the City*

DAN THOMPSON

creator of *Rip Haywire*

Richard writes and draws his comic in such a warm, fun way—always balancing the truths of each personality just enough for the humor to show through in their adversities. Richard Thompson is what every cartoonist aspires to be.

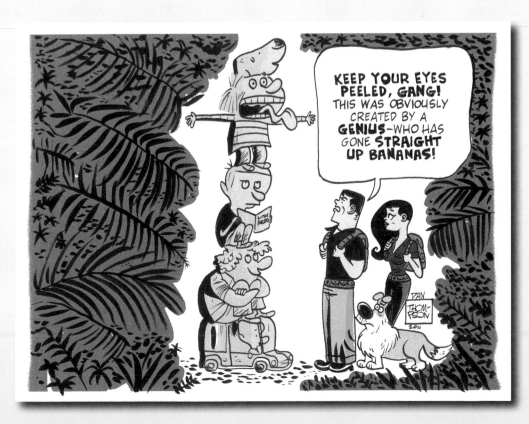

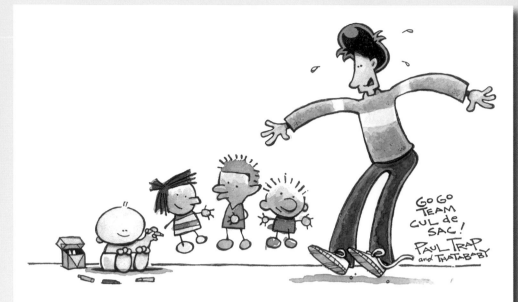

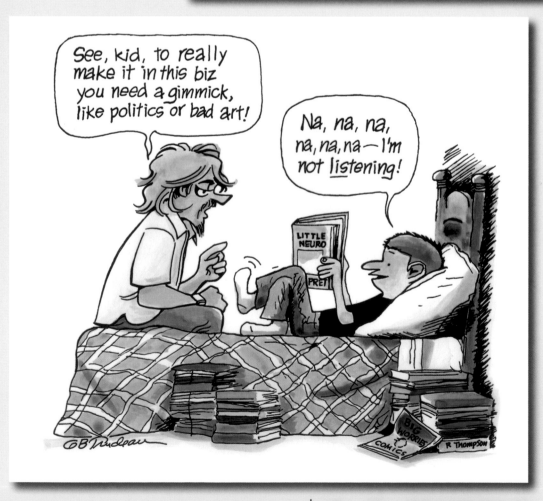

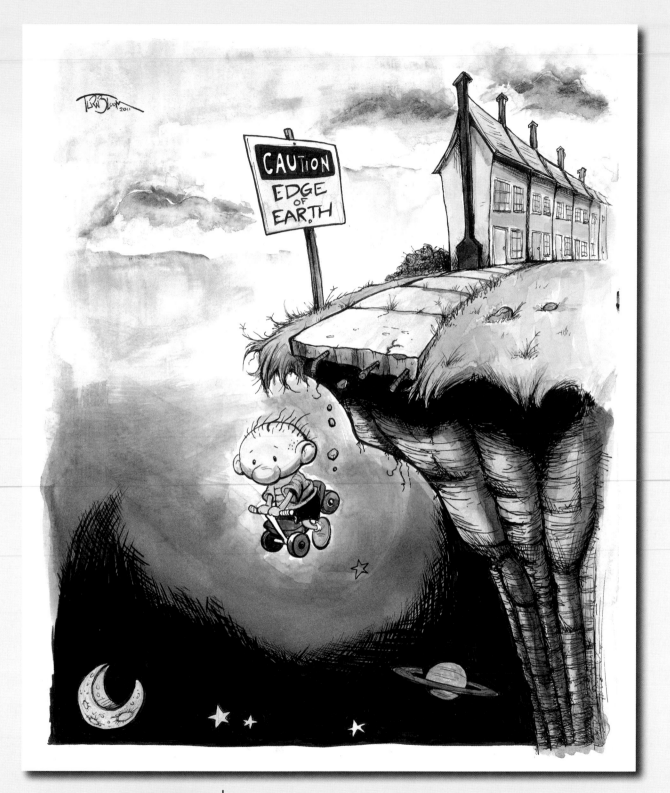

LUCAS TURNBLOOM

creator of *Imagine THIS*

Richard is one of the kindest, most talented people I have ever met. Not only is he an inspiration to me as an artist but he's also an inspiration to me as a person. When I first learned what Team Cul de Sac was all about, I immediately wanted to help. Contributing an illustration was the very least I could do to help such a great cause and a great person. Thank you for the inspiration, Richard.

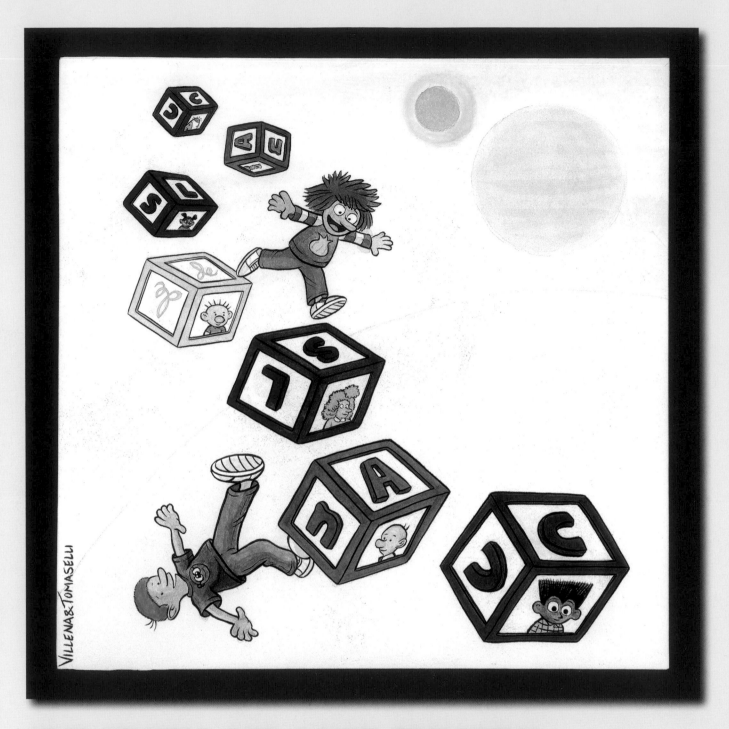

JOSE VILLENA AND DAVID TOMASELLI

creators of *Onion & Pea*

This watercolour was born from a dream that Villena had, and that's why the main theme of the drawing is a fantasy trip through the dreams of the main characters in *Cul de Sac*. It is a tribute to that childhood world that Richard Thompson's strip so marvelously portrays. The watercolour can be turned 180 degrees to be seen from your favourite character's perspective (Alice or Petey).

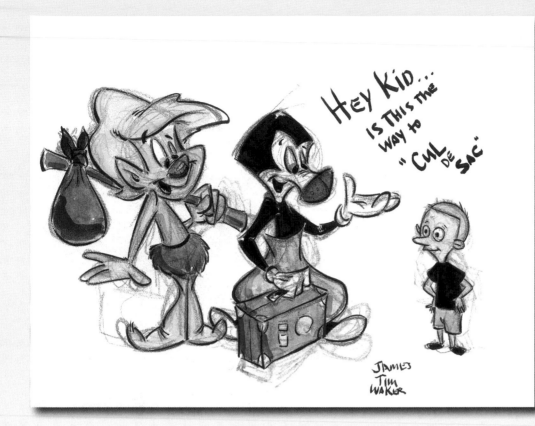

JAMES TIM WALKER

director and animator

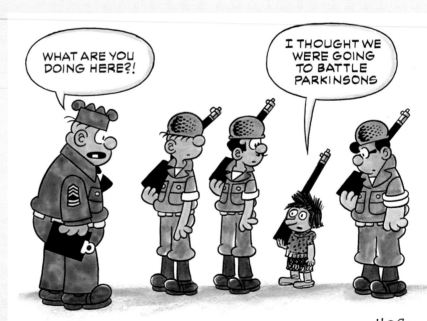

MORT WALKER

creator of *Beetle Bailey* and
Hi and Lois

It was a pleasure meeting Richard for the first time at the NCS annual dinner and handing him the Reuben Award as the best cartoonist of the year. He's such a nice guy, and admirable for achieving a hard-won success while fighting his affliction.

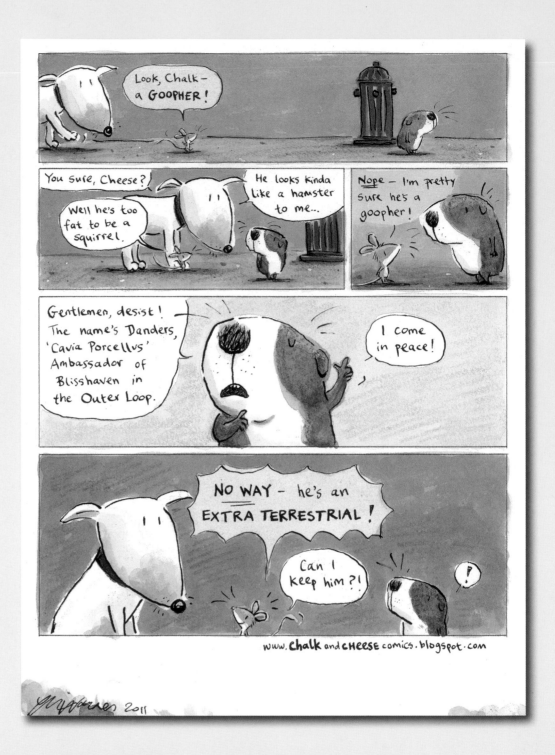

TIM WARNES

author and illustrator, creator of *Chalk & Cheese*

What is it about *Cul de Sac* that I love so much? Well, first, there's those wild, scratchy lines, which give Richard's drawings so much life and energy and make it such a pleasure to look at. Secondly, it's so well written and observed. But maybe that's too analytical. The bottom line is *Cul de Sac* is so darn funny. It really truly makes me (and my son, also a comic book aficionado) laugh out loud. So thank you, Mr. Thompson, for brightening my days and inspiring me to greater things. And thanks to Mr. Danders, for gracing *Chalk & Cheese* with your presence. That was just too good an opportunity to pass up.

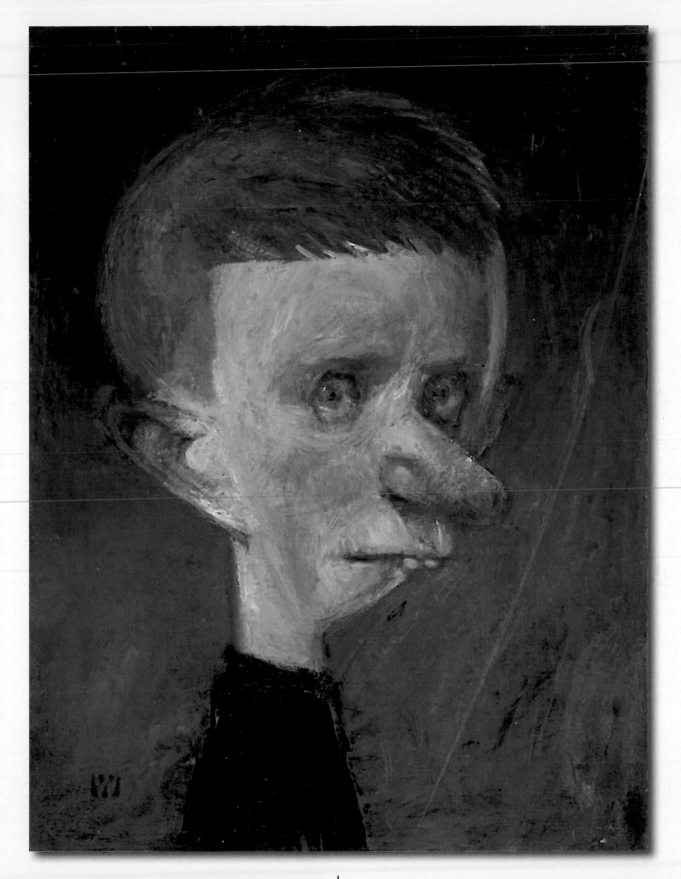

BILL WATTERSON

creator of *Calvin and Hobbes*

MO WILLEMS

author and illustrator of *Don't Let the Pigeon Drive the Bus!*

It's a near-miracle to find so much wit, snarkiness, compassion, vibrancy, unexpectedness, serenity, bravery, and goofiness existing simultaneously; and I'm not sure if I'm talking about Richard or his comic strip. Either way, I'm jealous.

EMILY WILSON

illustrator

I can't help but see a bit of myself in Alice. Yes, we would fight for the last sarcastic word, but I'd like to think that we would make great friends.

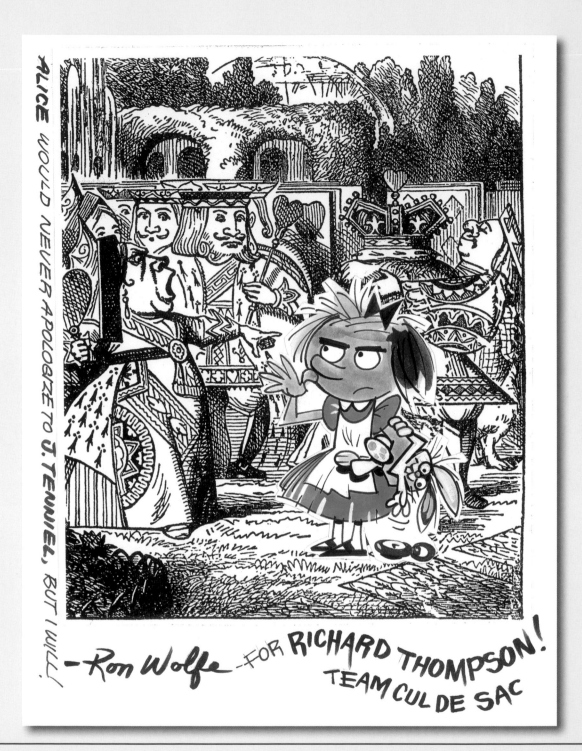

Alice would never apologize to J. Tenniel, but I will. — Ron Wolfe. For Richard Thompson! Team Cul de Sac

RON WOLFE

cartoonist

I've been admiring Richard's cartoon style since before *Cul De Sac*, going back to his wonderful illustrations for Joel Achenbach's column *Why Things Are*, in the *Washington Post*. One reason I did his drawing *Alice (Otterloop) in Wonderland* is that my own style is the opposite, every line worried over. I thought it would be a snap to reproduce Richard's sketchy look. I know better than to fall for something that looks easy, but the thing is he makes it look soooooo easy, and it's not. Well, but, it is for him, I'd still like to think.

The other reason is, my dad had Parkinson's. He always liked my cartoons, even the bad ones with which I littered the house as a kid. He always held out hope that I'd come up with some better stuff along the way, and I bet he'd like this one.

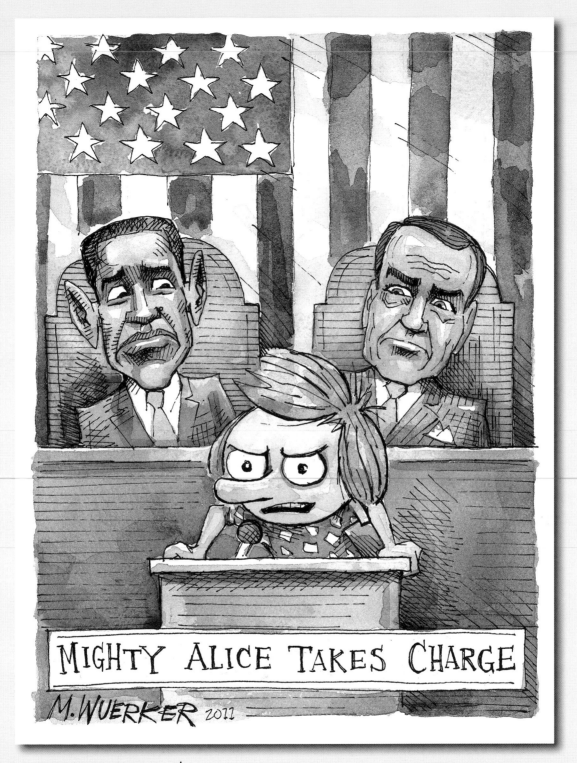

MIGHTY ALICE TAKES CHARGE

M.WUERKER 2011

MATT WUERKER

cartoonist, POLITICO

If there was such a thing as a cartoon farm where you could crossbreed the pure comic genius of a Searle with the staggering originality of Steinberg, mix in the inky virtuosity of Levine and the timeless charm of Rowlandson, you'd end up with the singular wonder that is Richard Thompson. He's unique, a cartoon chimera, a cartoonist's cartoonist . . . whose big-hearted imagination and gifts as a draftsman put the rest of us to shame.

CRAIG YOE

artist and publisher

Everybody here is kissing up and saying how great Richard Thompson's cartooning is. It's embarrassing! Let me offer a different perspective: Richard Thompson's comics stink! Of course, that's entirely a falsehood, but at least it's refreshingly different, huh? And about the man himself: He's a poopiehead! OK, there's not a whit of truth in that, either! But, at least I'm not sickeningly droning on and on, saying he's so utterly wonderful, like everybody else and their brother, even if it is true! You're welcome!

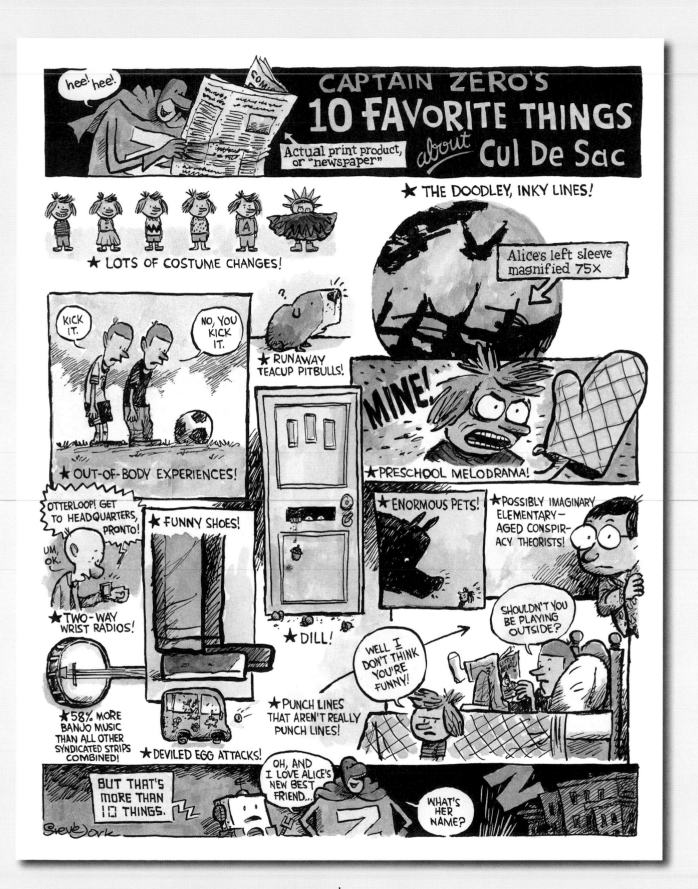

STEVE YORK

editorial cartoonist

DAVID ZINN

illustrator and teacher

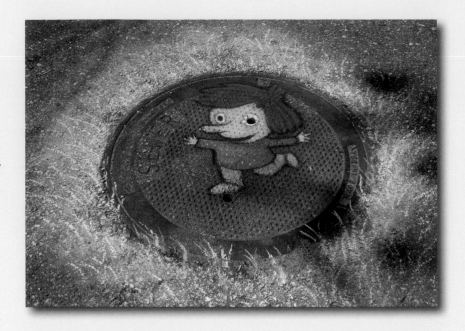

The first time I tried to imitate Richard Thompson's characters, I learned an important lesson about myself and the people I draw. I had always prided myself on the subtlety of my characters' noses; they were restrained, vaguely curved lines that gave a minimalist nod to the nasal overhang and nothing more. Then I tried to draw Alice Otterloop, and had to go back several times to double-check. Was her nose really so expansive and askew? So unrestrained? So . . . big?

As soon as I committed myself to her impudent proboscis, a startling change spread through my sketchbook. Knees and elbows jutted; eyes darted; hair threatened to blow away entirely. Characters who had previously stood quietly and stared at the ground suddenly yawned and stretched as if they had been released from a witch's spell (or maybe put under one). Finally, my drawings are awake. They break frames and ask inappropriate questions. Even the characters who continue to stare at the ground do so with an intensity that is gratifying to see. Thanks to Richard Thompson, I have learned the Rule of Alice: Both cartoon life and real life benefit from moments of jagged, passionate nasality.

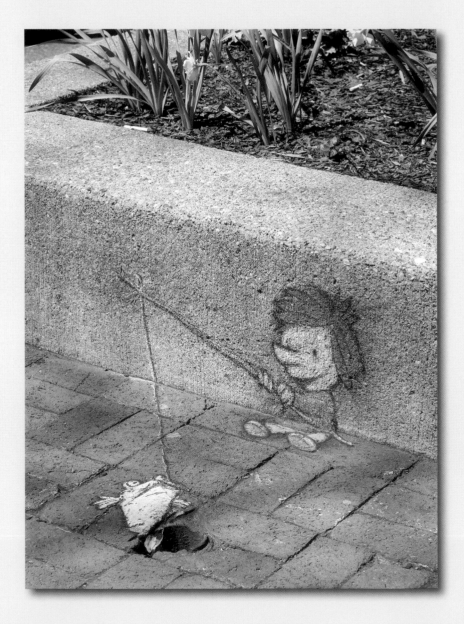

CREDITS

INDEX OF CONTRIBUTORS